LIGHT WARRIORS

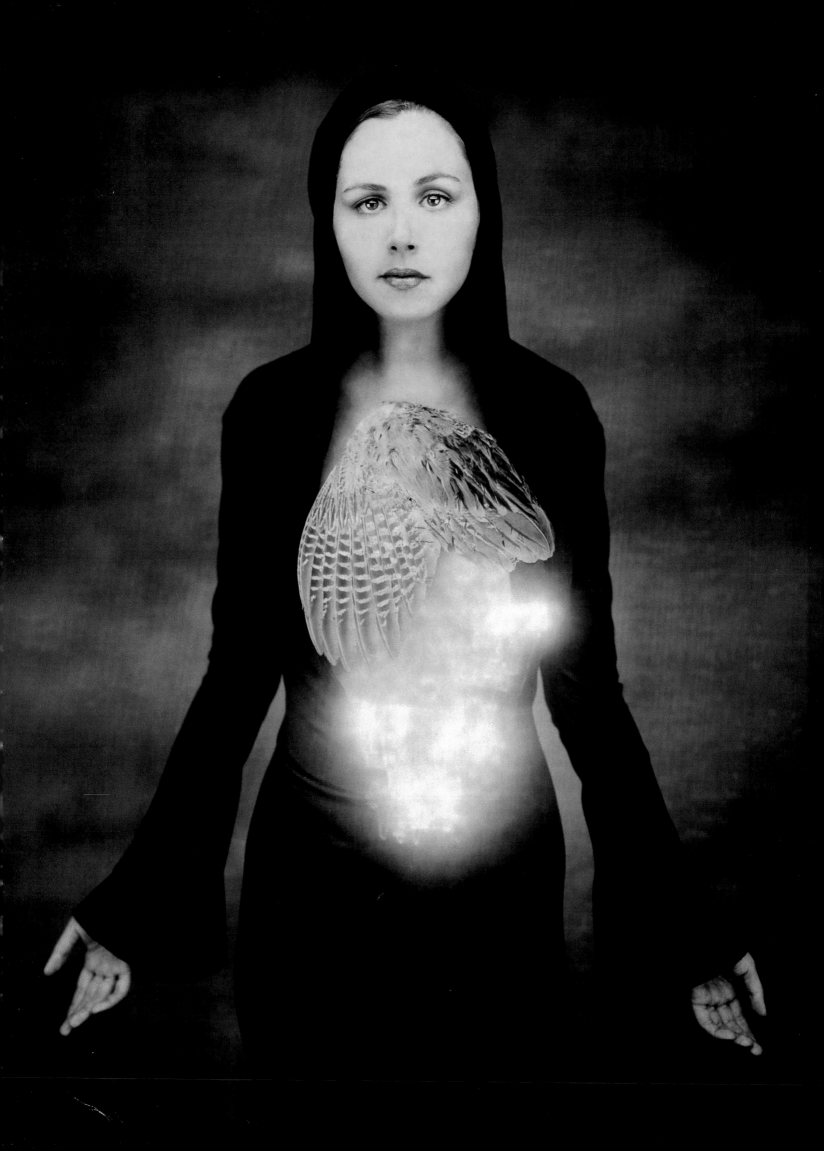

JOYCE TENNESON
LIGHT WARRIORS

A BULFINCH PRESS BOOK

LITTLE, BROWN AND COMPANY

BOSTON NEW YORK LONDON

First edition

Library of Congress Cataloging-in-Publication Data

Tenneson, Joyce.

 Light warriors / Joyce Tenneson.

 p. cm.

 ISBN 0-8212-2698-3

 1. Photography of women. 2. Women—

 Portraits. 3. Portrait photography. I. Title.

TR681.W6 T48 2000

779'.24—dc21 00-055463

Bulfinch Press is an imprint and trademark of Little, Brown and Company (Inc.)

All author proceeds to benefit The Light Warriors, a nonprofit organization
For more information on Joyce Tenneson's work or The Light Warriors,
please visit her Web sites at www.tenneson.com and www.lightwarriors.org

Designed by Lindgren/Fuller Design
Color separations by Martin Senn

Printed and bound by Amilcare Pizzi, Milan, Italy

To my mother, Anna, who was an identical twin,
and through whom I glimpsed the possibility of
complete connectedness—the eternal circle

Josephine and Anna, 1935

INTRODUCTION

This series of photographs, which I call *Light Warriors,* emerged more effortlessly than any other series I have done over the years. My work has always had an autobiographical element. For me, photography is a kind of visual diary—it allows me to probe emotions and inner realities that by their very nature are invisible but are powerfully present in all of us nonetheless. What thrills me is when I see something unexpected and wonderful, even if it is at times disturbing as well. I am bored with surface beauty; what fascinates me is life's complexities, the darkness as well as the light.

I've always been absorbed by the workings of the female psyche, perhaps because I grew up in an environment that was almost completely feminine. My mother had eight sisters, who all lived nearby, and we lived on the grounds of a convent—an almost surreal experience for a child who was naturally curious. My childhood also showed me the power of ritual, and gave space to the unknown. In ancient times, women from Asia to Egypt and Ireland taught the earth's mysteries and provided the light of awareness and wholeness in the family. I believe we still have these gifts.

In my work, I try to open myself and let the unconscious take over—and I am always surprised by the transformations that emerge in front of the lens. I don't give my subjects any specific directions. I just provide a safe space for them to be open, to let down their external shields, and to expose an essence or kernel of their being that is normally secret or hidden. For me, the portrait session is an intimate moment of sharing and collaboration where we feel free to show our inner selves. Of course, this is all intellectualizing something that is intrinsically private and nonverbal. It is hard for me to analyze or put this process into words—we never know in advance what the resulting photograph will unveil. My subjects are not role-playing. By presenting and revealing themselves to us, they are holding up a mirror for the viewer's own inner experiences. It is hard for any of us to relax our powers of self-protection, but each of these women has expressed her delight at being able to drop the expected façade, and to let her inner core escape into the light—if only for a moment.

I was drawn to photograph the people in these pages because I saw something in them, an inner power or radiance that resonated with my unconscious. *Light Warriors* is the name that

gradually evolved as a title for these photographs. The women I photographed all make me feel as if they are on a journey or search. Their ages range from twenty to fifty, and they are from many different countries and cultures. To me they are pilgrims—they express emotions or dimensions that surround us at different stages in life. By trying to reveal their essence, I want to celebrate the beauty and complexity of what it means to be a spiritual warrior—to offer oneself to the world authentically, to flex the courage muscles, to share what it means to be human. After all, we are all pilgrims on this earth. Part of the beauty of being human is our capacity and desire for connection. As Eudora Welty said, "I come from a sheltered life, but a sheltered life can be daring as well. For all serious daring comes from within."

The women I photographed for this book are friends who arrived from many directions. Marcia (p. 105) is a former student who had just finished chemotherapy. During the workshop she shed her wig and was shocked to hear us all proclaim her eloquent beauty. Bless (p. 99) is the daughter of a dear friend. I met April (p. 39) on the subway last spring and Lisa (p. 91) in the elevator going to work. I've known Susan (p. 61) for over a decade. Her resemblance to her daughter is visually and psychologically fascinating to me. I met Katherine (p. 107) at an exhibition. When I heard she was married to an artist from Senegal and had a daughter, I knew I had to photograph them together. And then there is Sheryl (pp. 12, 13). I first photographed her when she was pregnant. Through her regal summing up of all it means to carry new life, I relived a part of my own past. And when Marisa (p. 7) appeared, there was something compelling in her presence that echoed back to the person I see staring out from some of my early self-portraits. The pain, the vulnerability—it kept me awake all that night. It was only later I learned that Marisa, who was a dancer for the New York City Ballet, had recently contracted a rare virus, which settled in her leg muscles, and can no longer dance.

As I photographed each of these women, I asked them what was most important to them in their lives. This was all done while we were standing together, getting ready to take the pictures. I wanted a quick response, nothing ponderous or overly thought out—just a visceral burst. Here are a few responses:

The identical twins Erin and Heather (pp. 22, 23): Erin—"I'm secret, I'm stone." *Heather*—"It's hard describing to others what it means to be identical twins. We are duality—dark and light inter-acting—yin and yang. In ancient times people believed identical twins could bend or break nature to their will. They killed the second twin, which would have been me, to break the powerful bond they feared. I'm secret too, but I'm the strong one—I'll definitely protect Erin."

Dasha, who is from Russia (p. 67): "I don't know who I am, I'm just trying to figure it out. But for me, being a woman is about bringing the warmth, beauty, and love from inside you to those around you. In the United States, people don't speak about the soul and the heart the way they do in my country. But they are always talking about the past now in Russia—there is sweetness and sadness and nostalgia, all mixed together."

Ayla (p. 47): "I studied in India for a year. I wanted to learn how to go between worlds—to travel from the discipline of balancing a sharp, heavy sword on my head to sensual abandon."

Jasmine (p. 73): "I'm half Chinese and half Australian. I didn't realize how Chinese I was until I came to New York and met a lot of other Chinese. Growing up in Australia, I used to think my mother was very strange. Now I realize that what I thought were her eccentricities were actually part of her culture. Her humor was so different. I wasn't able to appreciate her fully. My father says he was Chinese in another life—he's an acupuncturist. I'm studying herbalism now—it's in my blood to heal."

Agola (p. 71): "People from Kenya are more open to the spirit—I miss that in New York. I feel like I have to protect myself here. But I carry a light inside—day and night I sense the light."

Patricia (p. 19): "I was brought up in a Mexican American family of ten children. I knew I had to try and make it in New York. It was hard when I moved here, but I had a built-in support system from my family, because my mother had instilled spiritual values in all of us."

Laura (p. 37): "What is most important to me is my son and family. And I want to use my creativity—either in acting, making a beautiful home, or in friendships. Success is not in a paycheck—I'll have a satisfying life if I'm excited to be alive every day."

Melinda (frontispiece): "I've always had a sense that I'm a bird trapped in a human body. When I was young, birds would fly into the house and get trapped. I was always the person to set them free. Wounded birds find me, and somehow it seems my destiny to help them back to life."

I am grateful to all those I photographed for trusting me. This book has been a labor of love. I feel privileged to have witnessed this complexity of emotions and dreams and longings. And it has convinced me that we are all more alike than we are different, and that the membrane between life and the spirit is most delicate when we are revealing ourselves. It has also taught me that art can be like an ancient ritual, where every thought is represented and respected as the miracle it truly is.

LIGHT WARRIORS

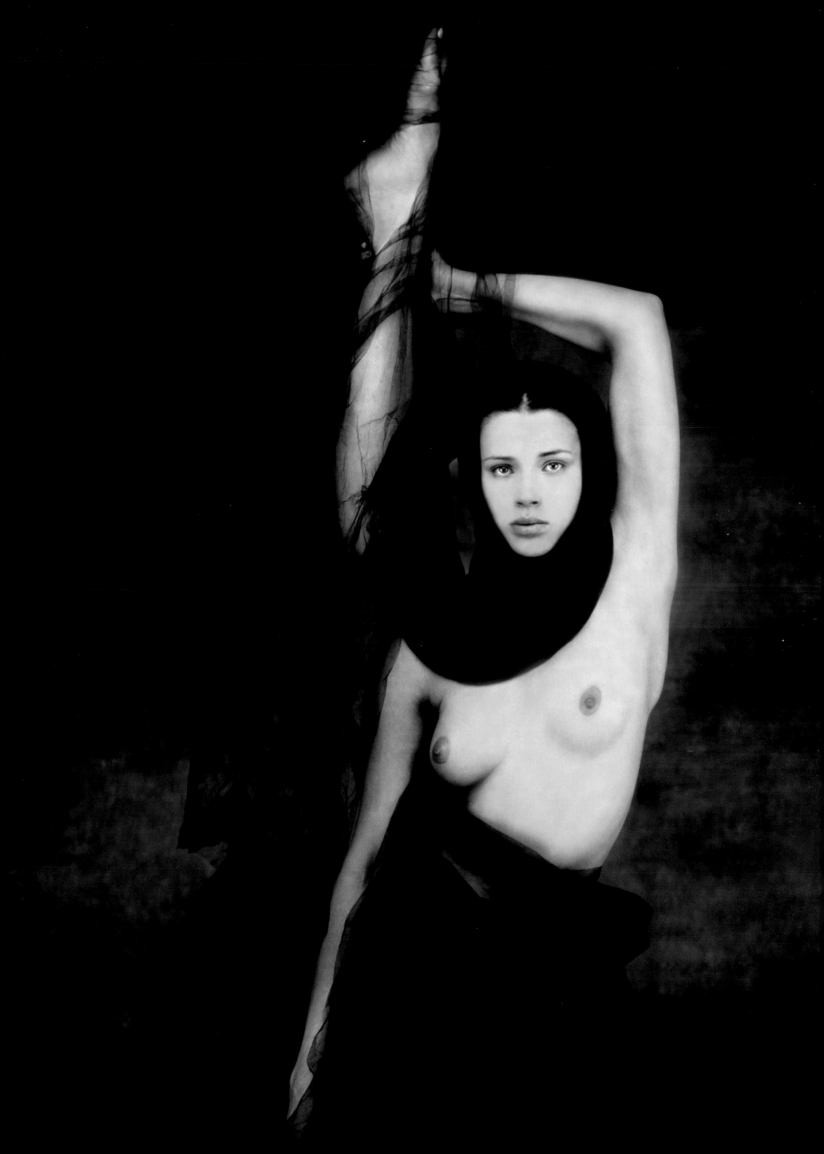

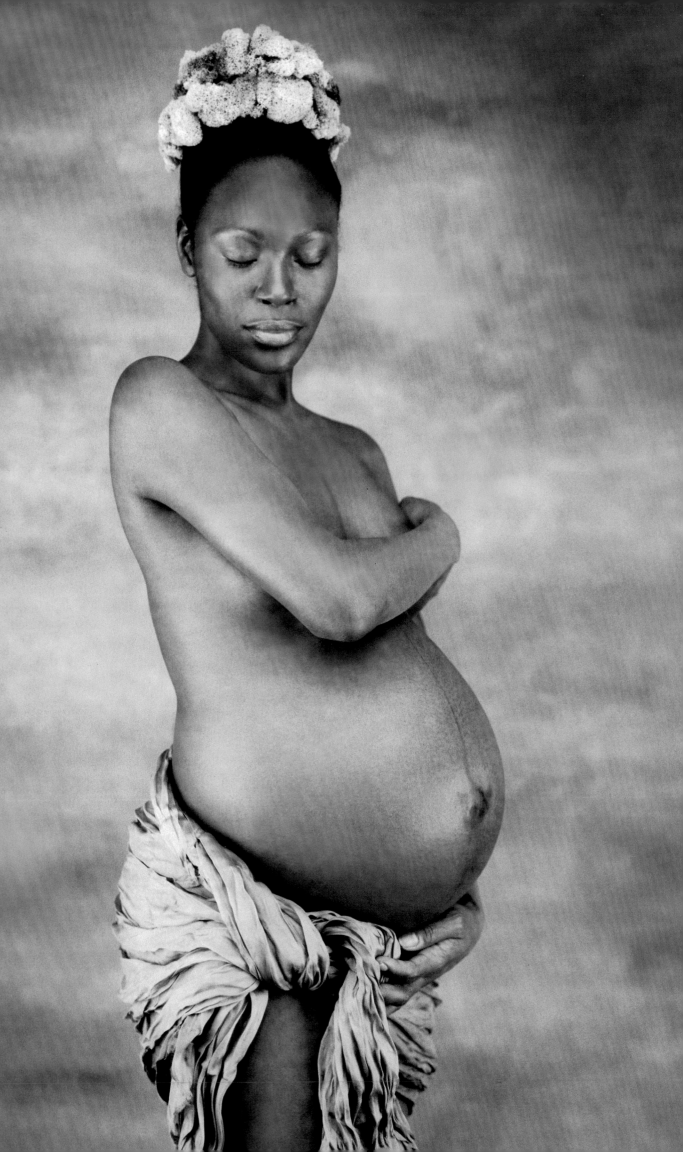

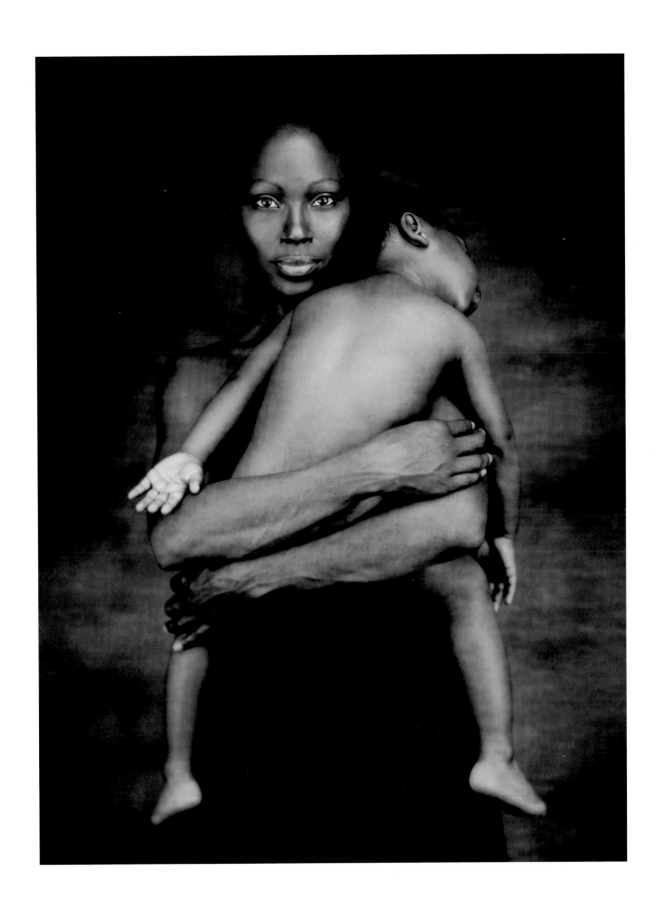

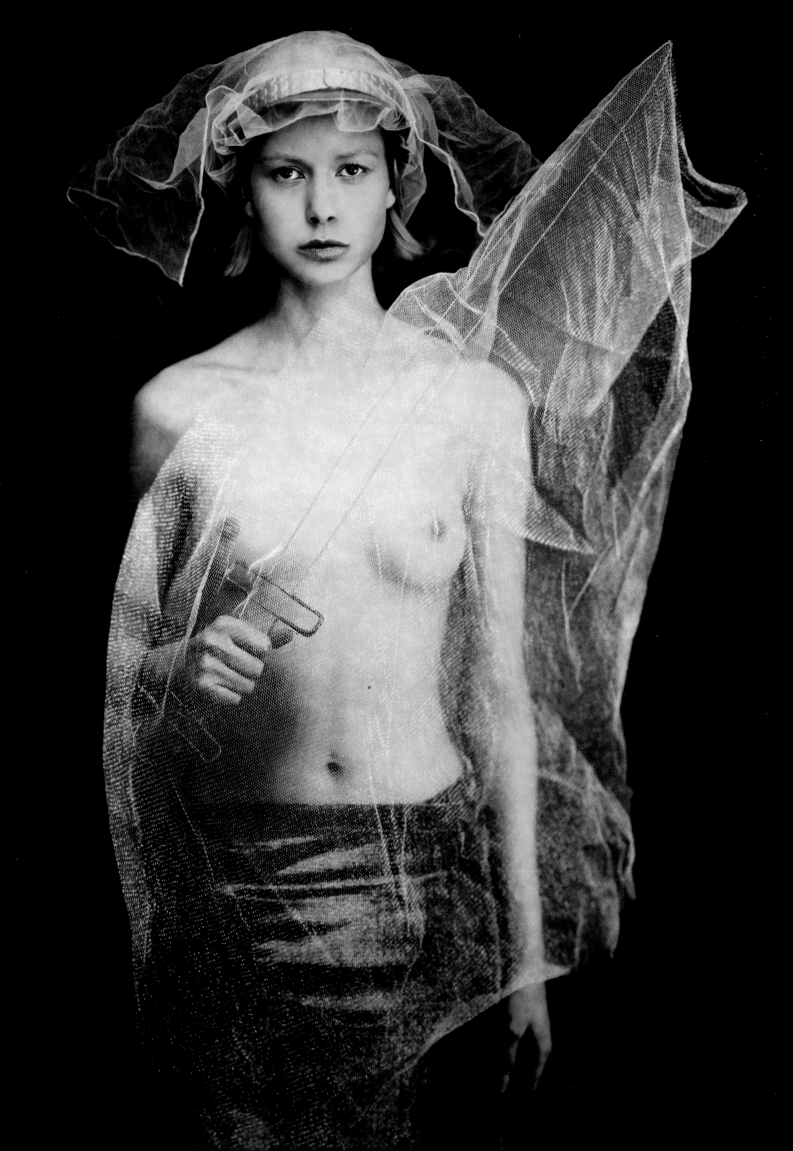

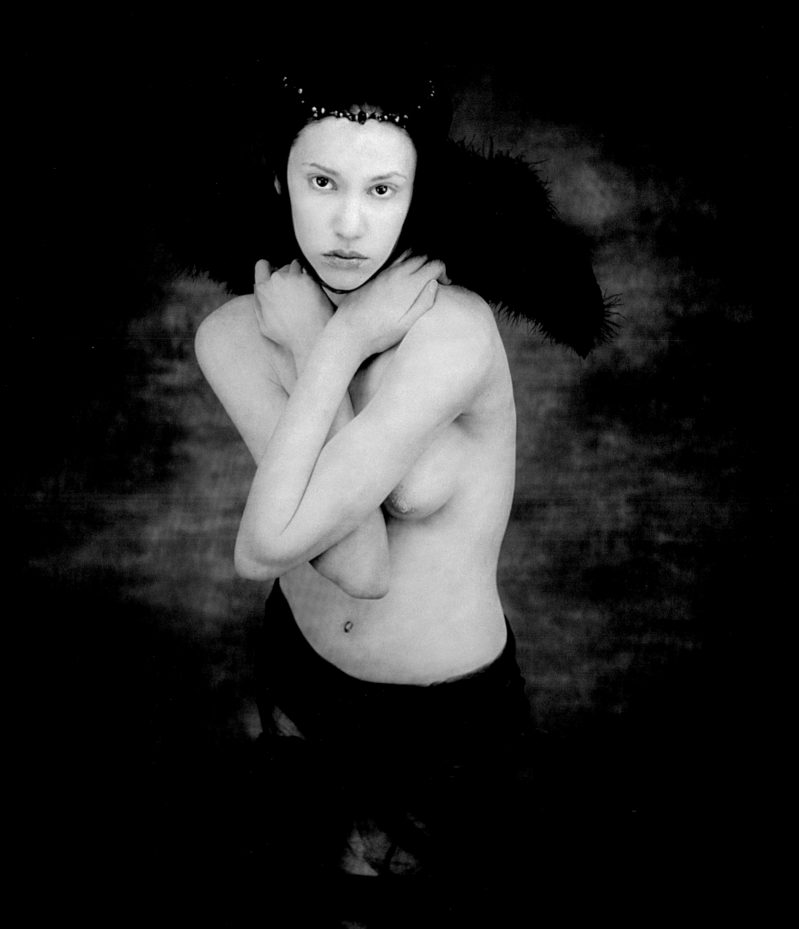

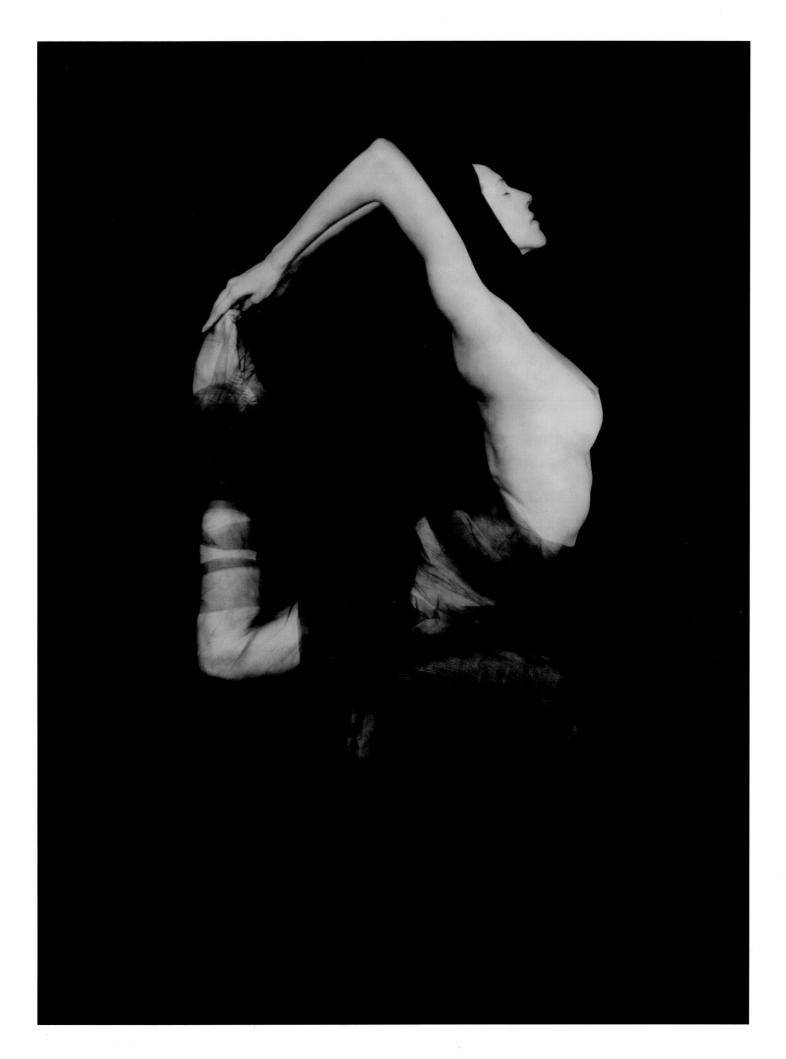

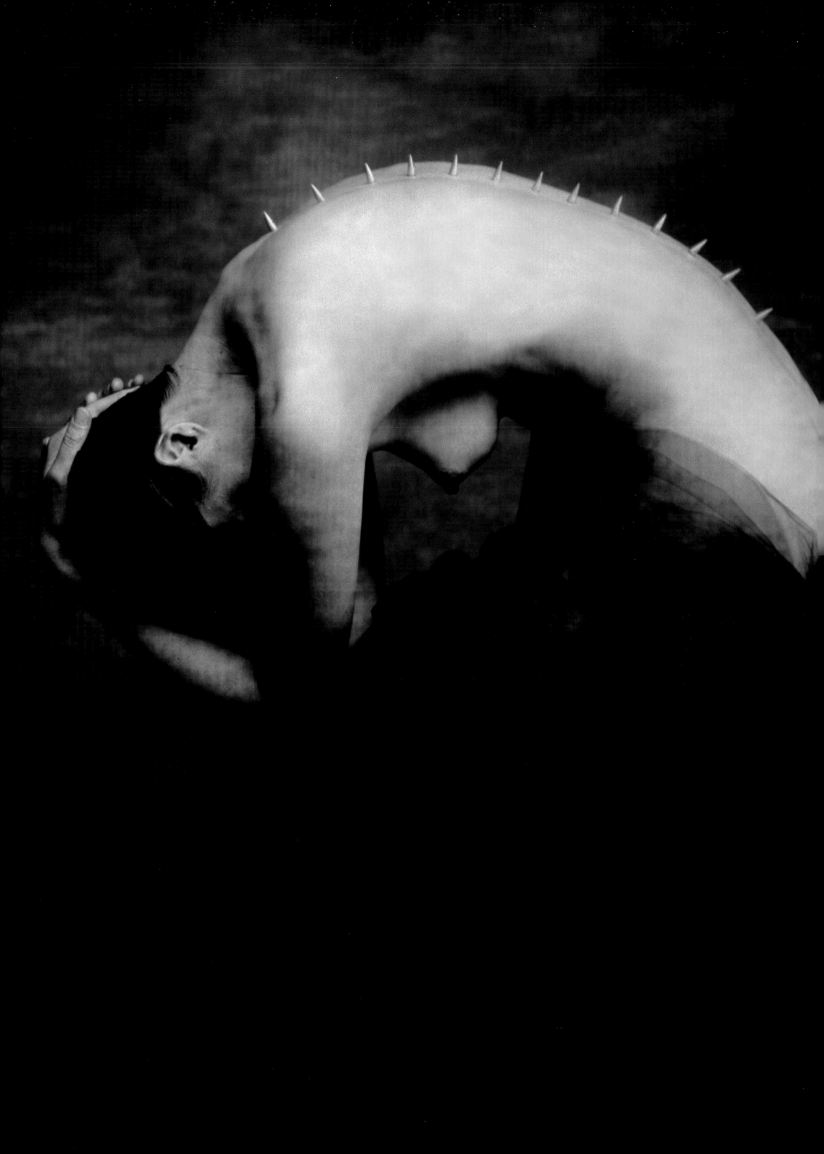

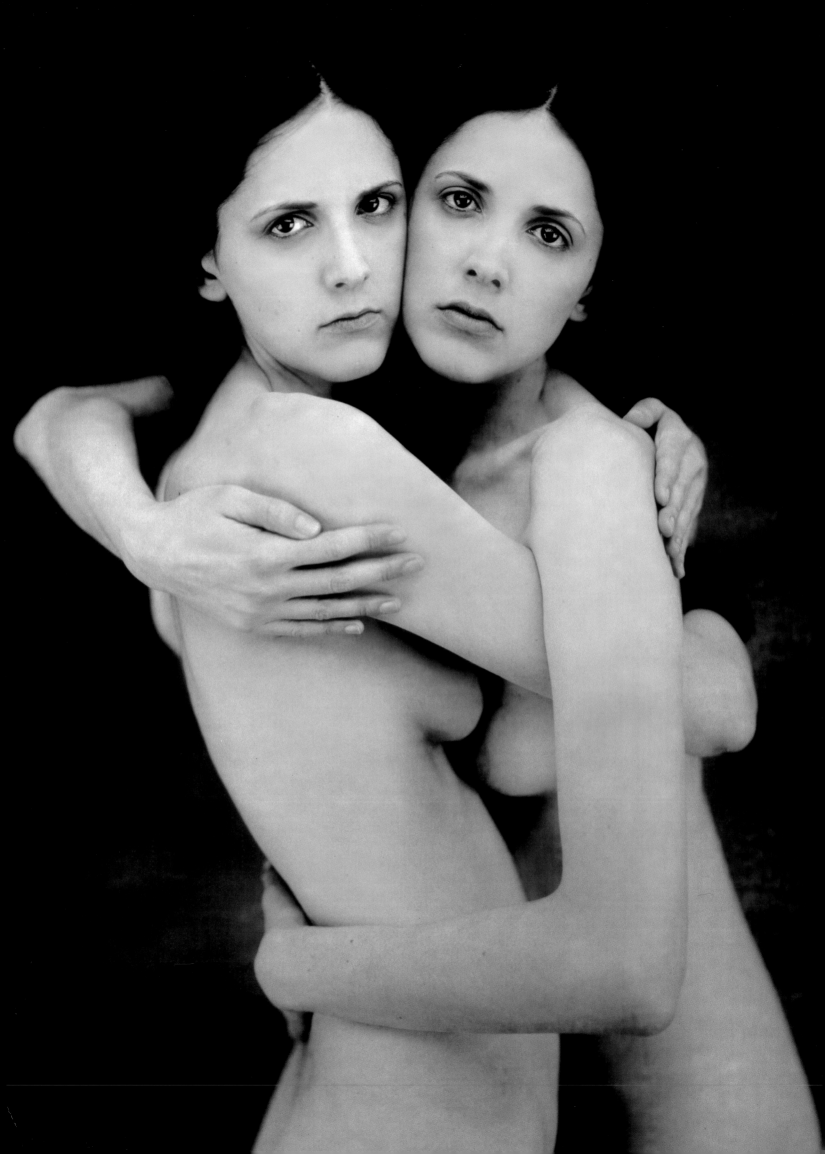

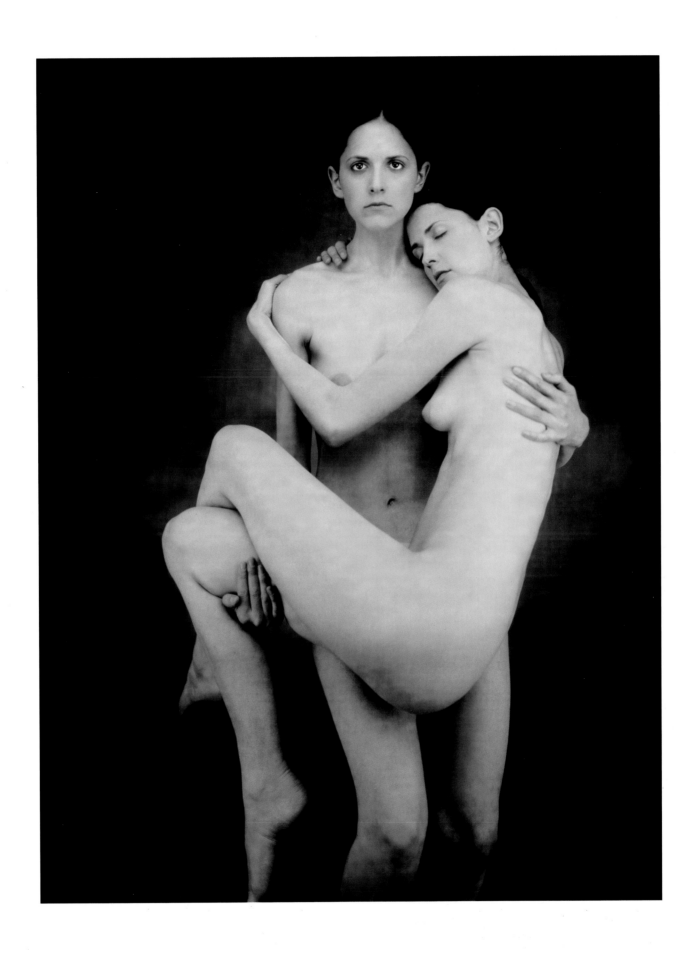

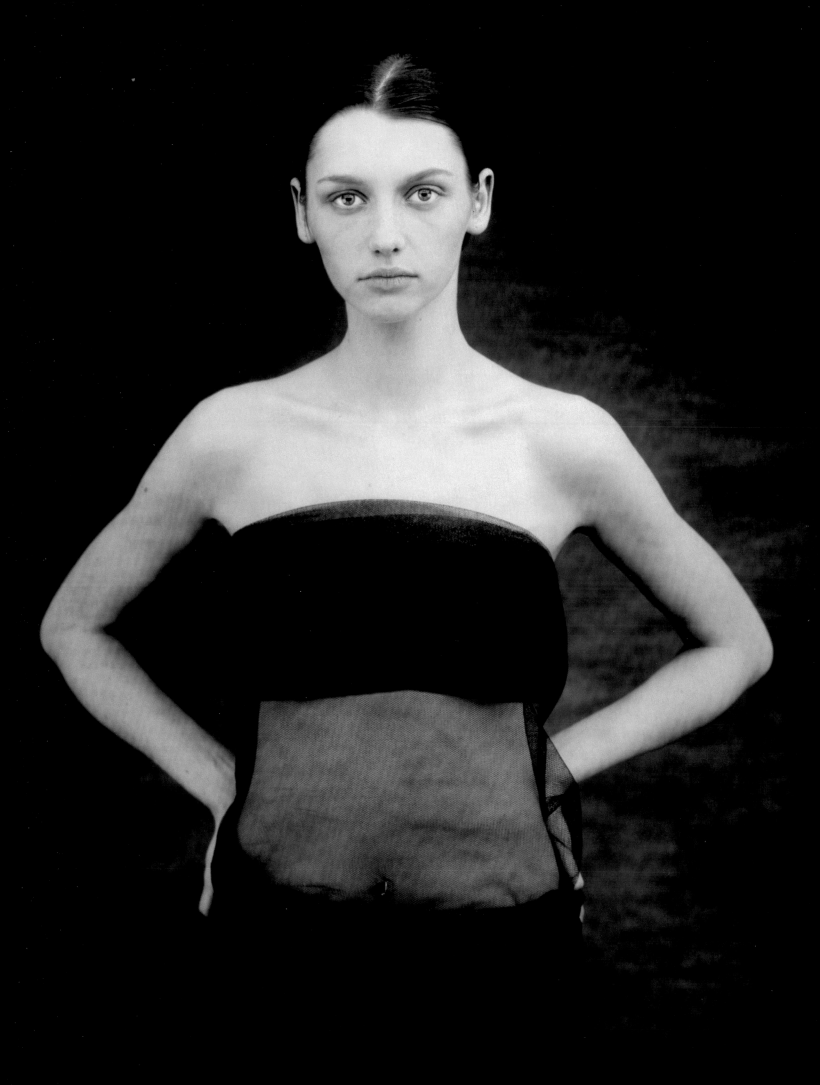

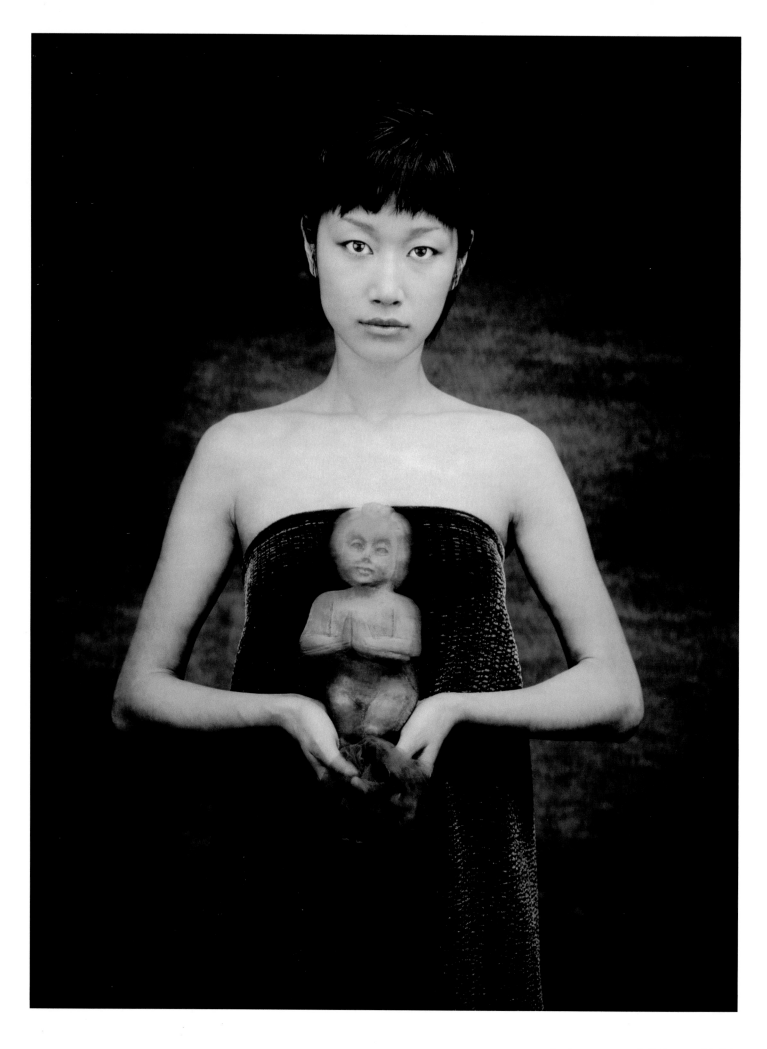

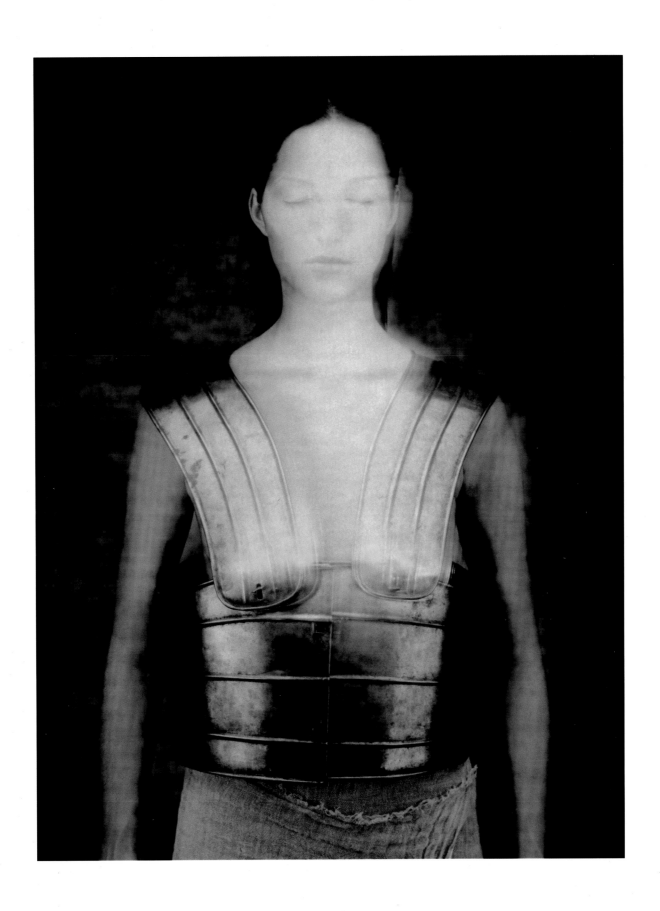

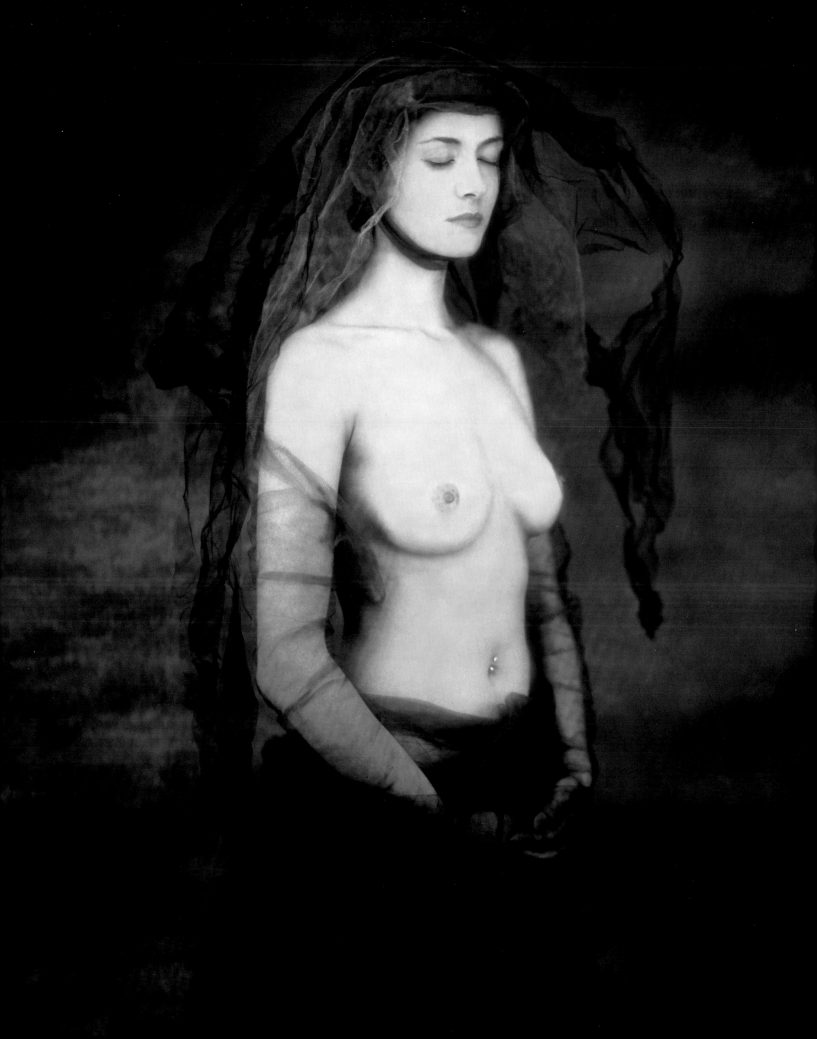

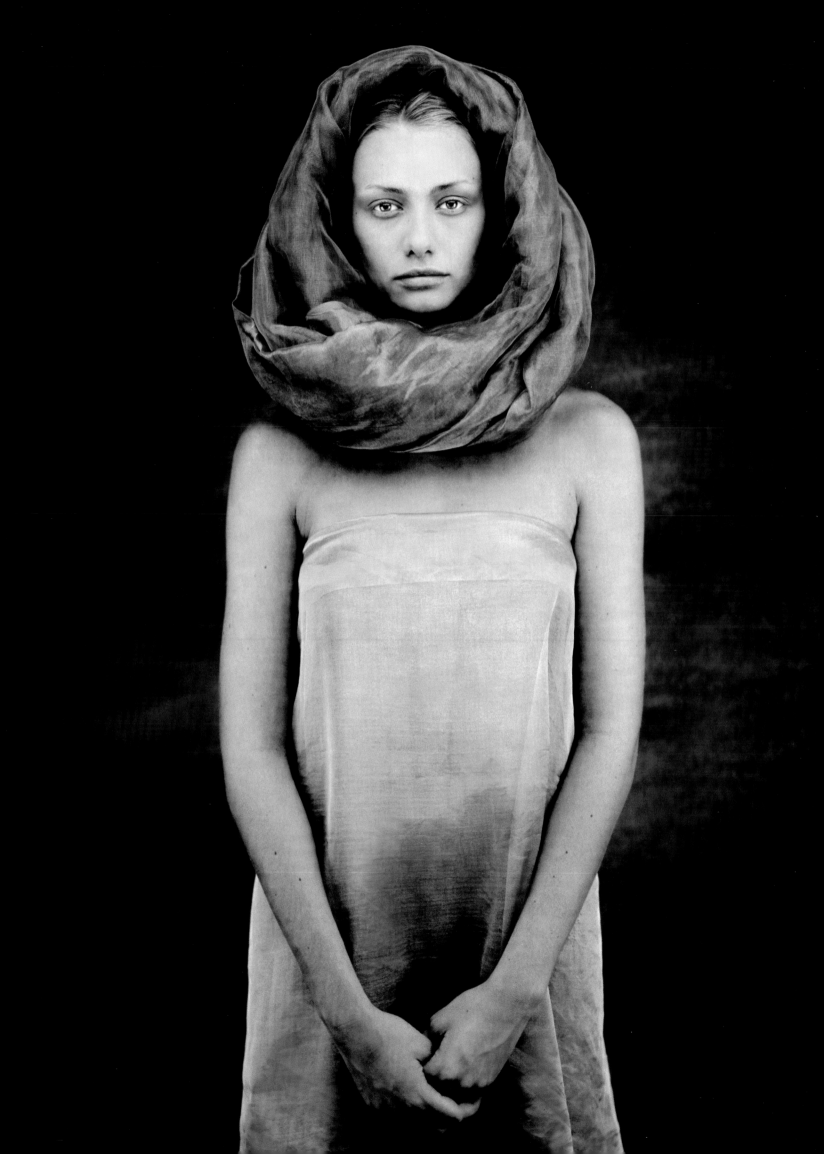

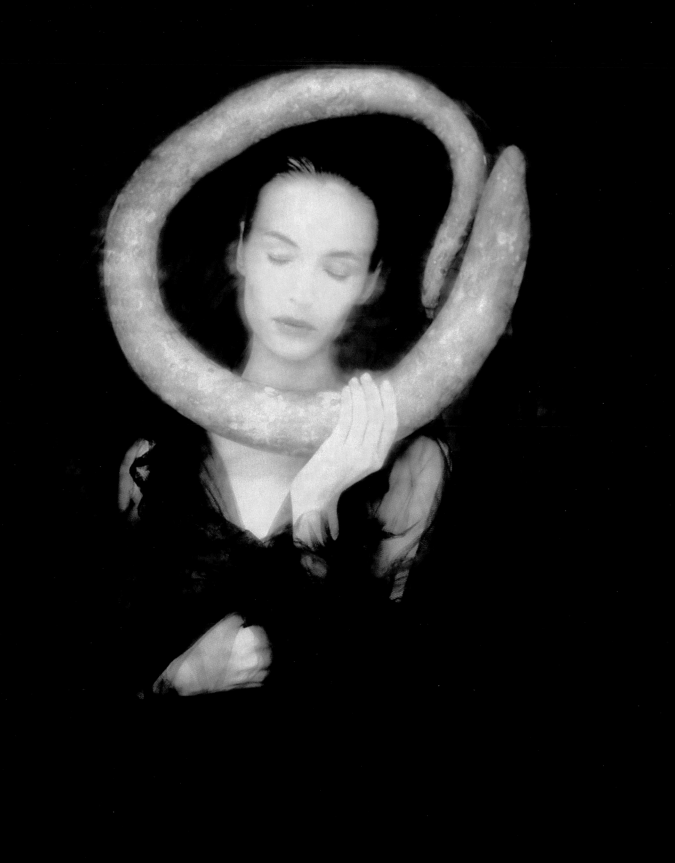

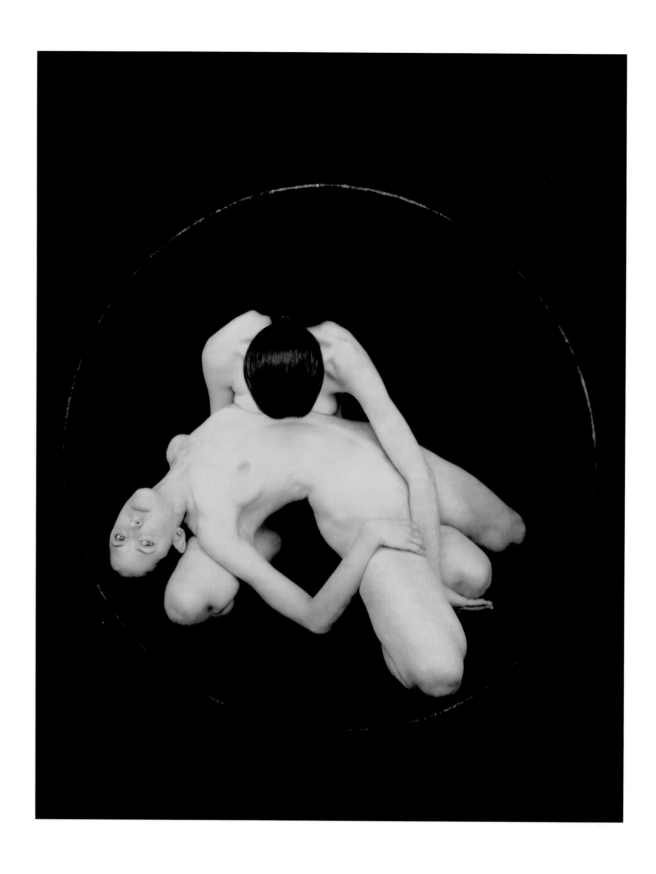

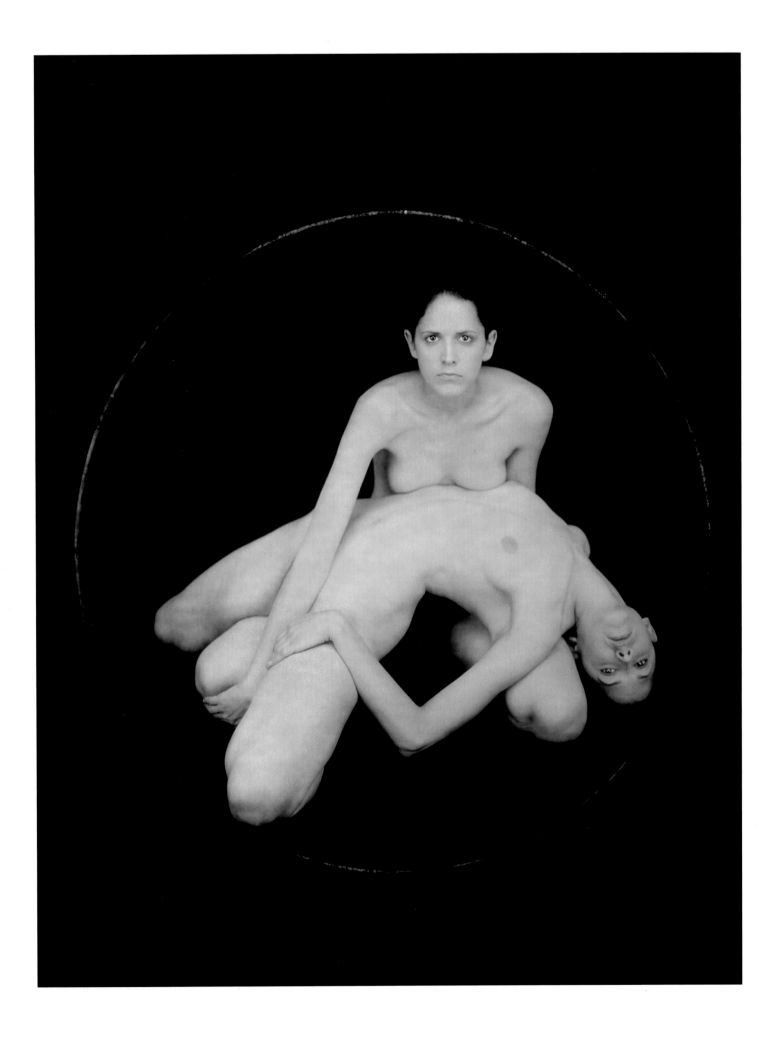

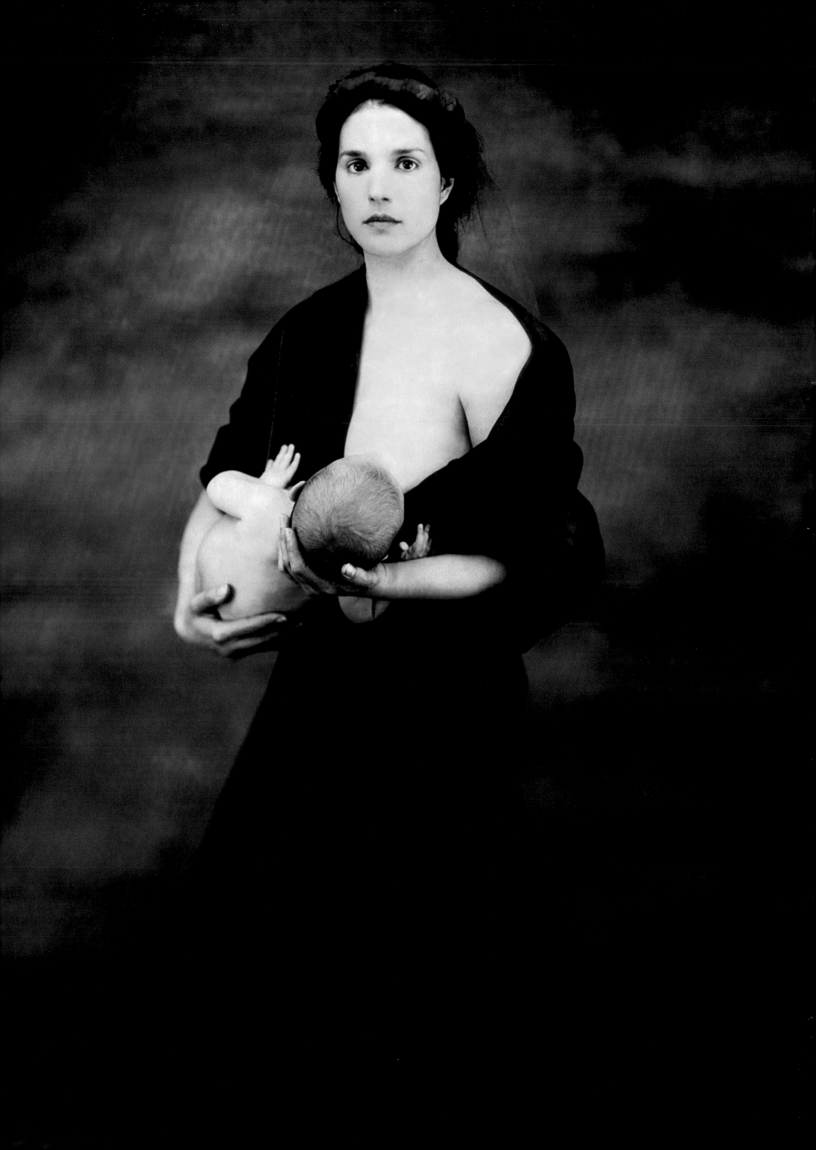

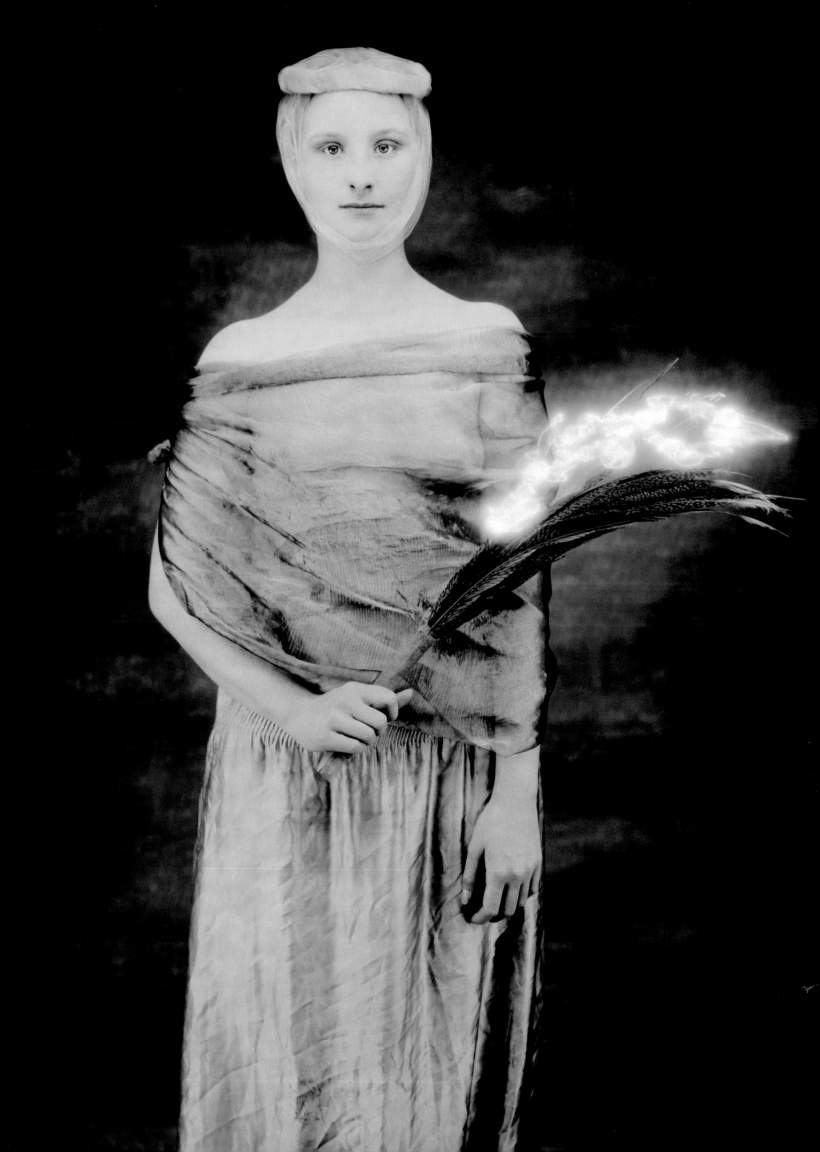

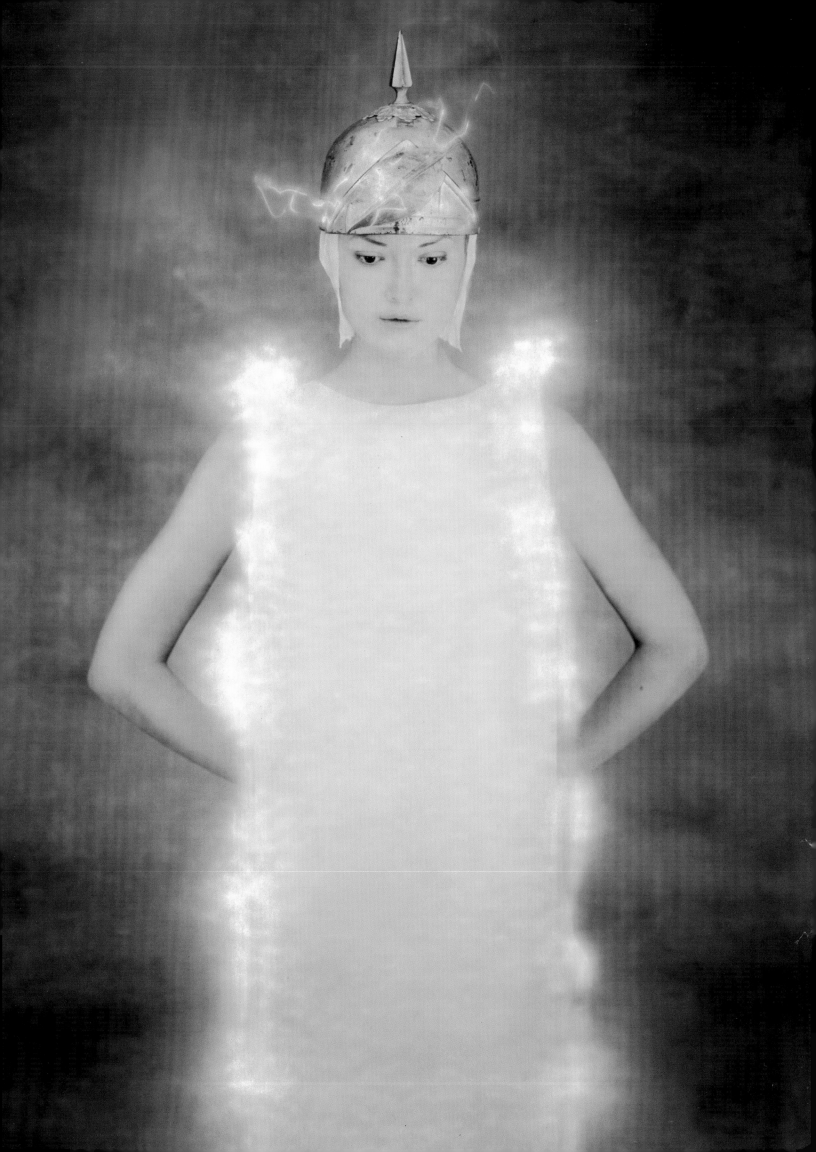

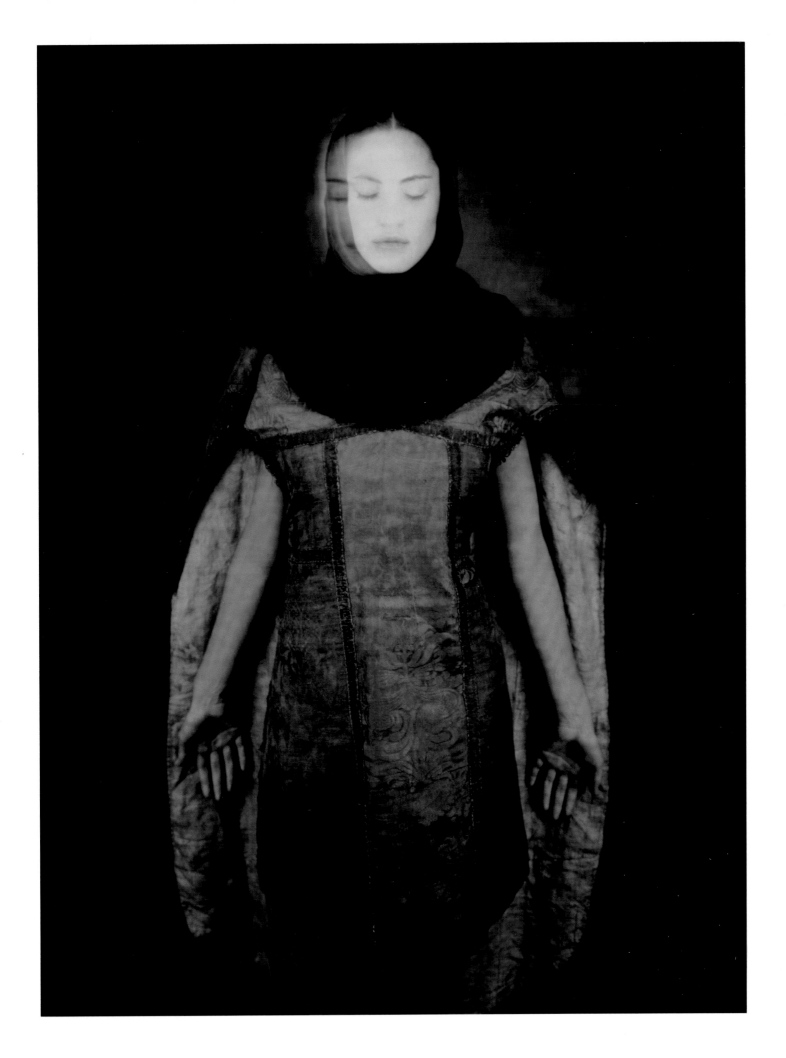

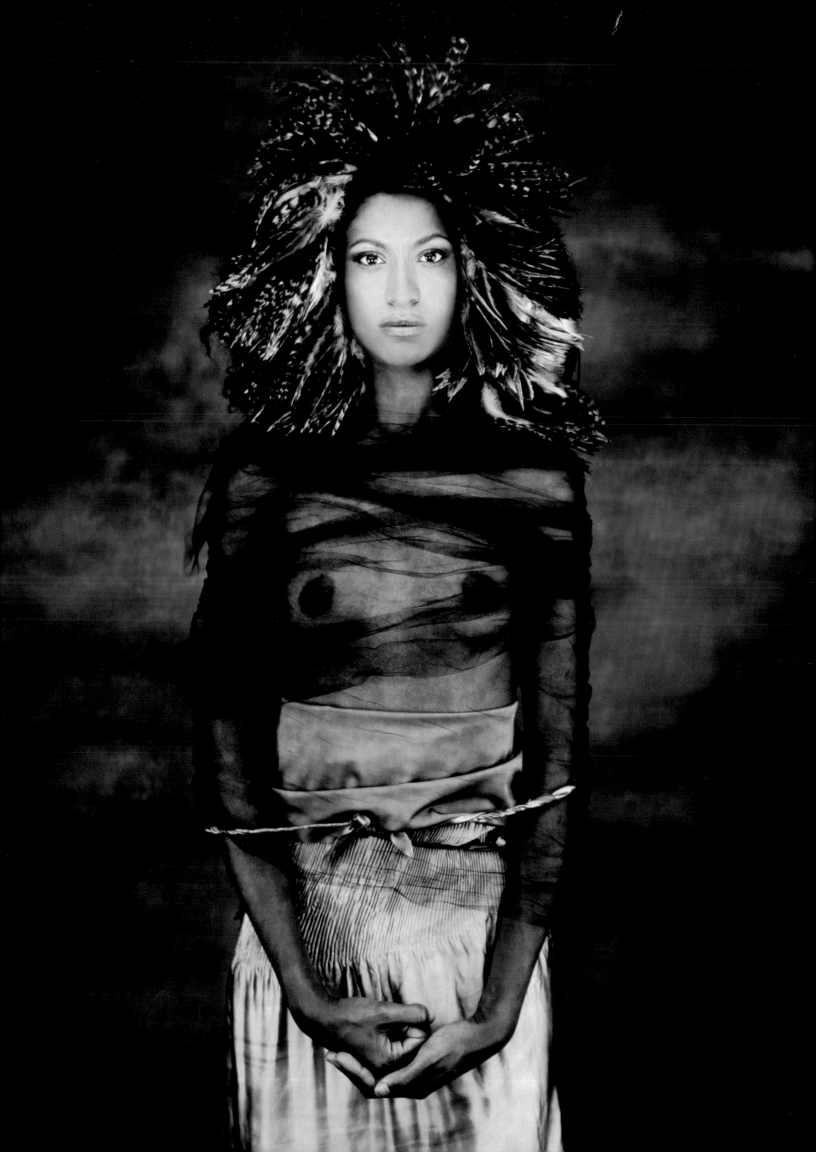

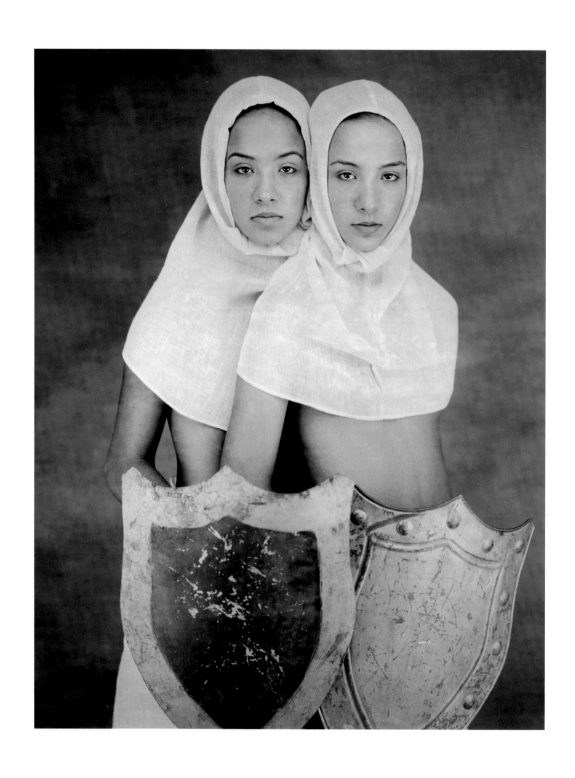

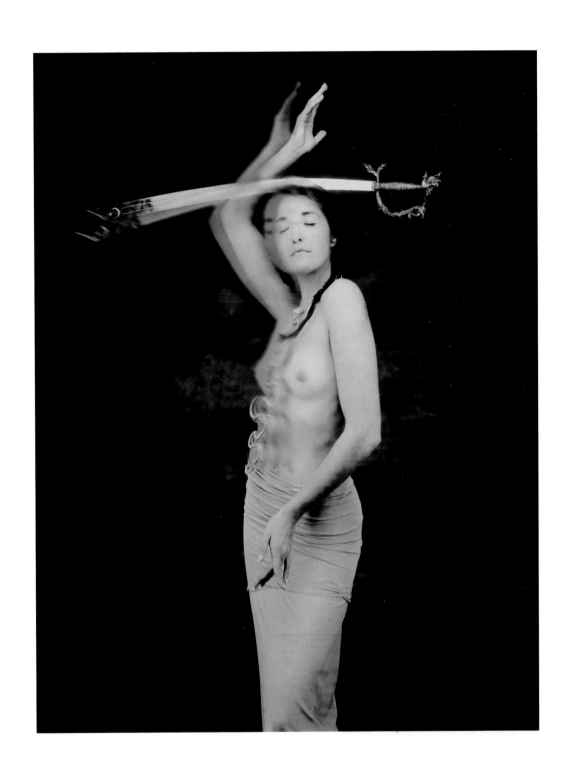

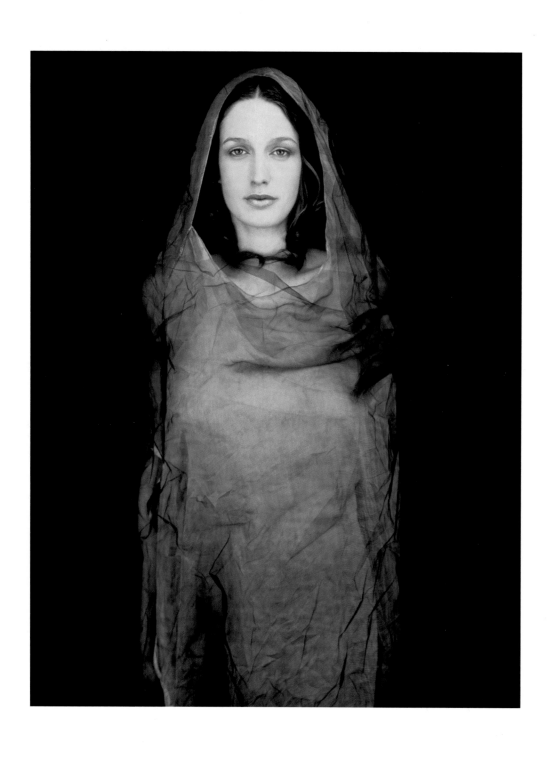

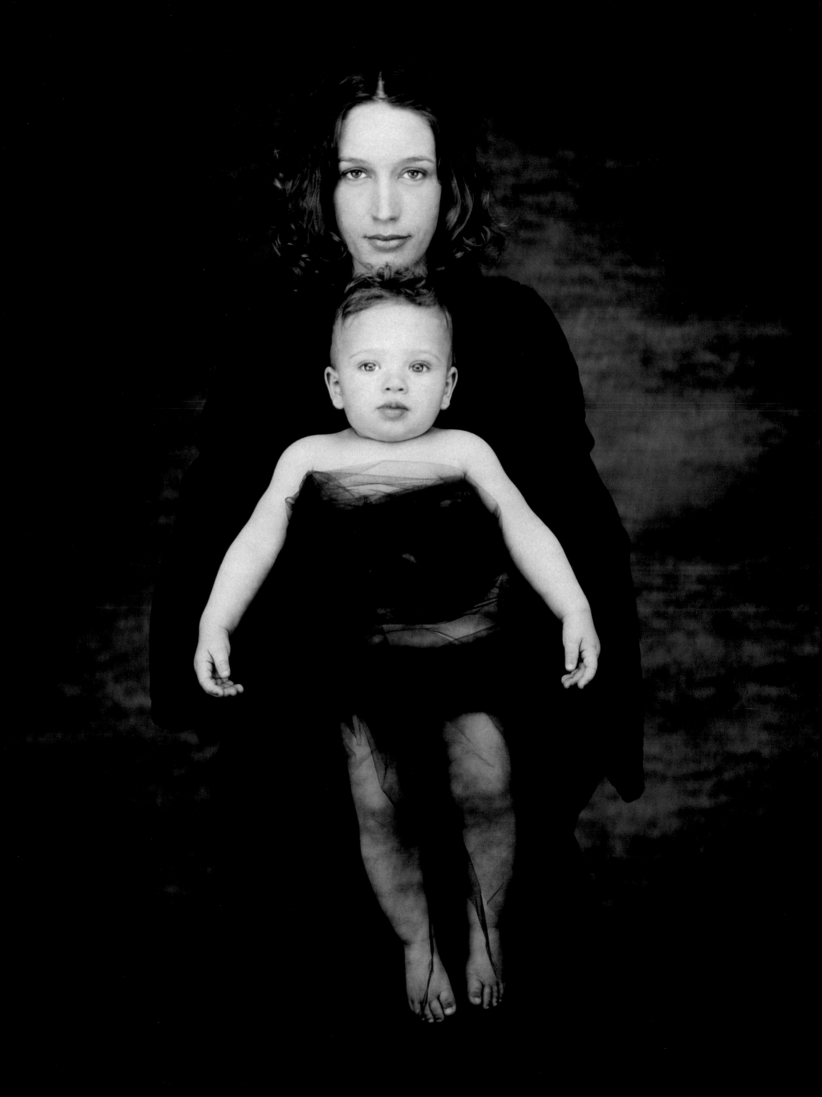

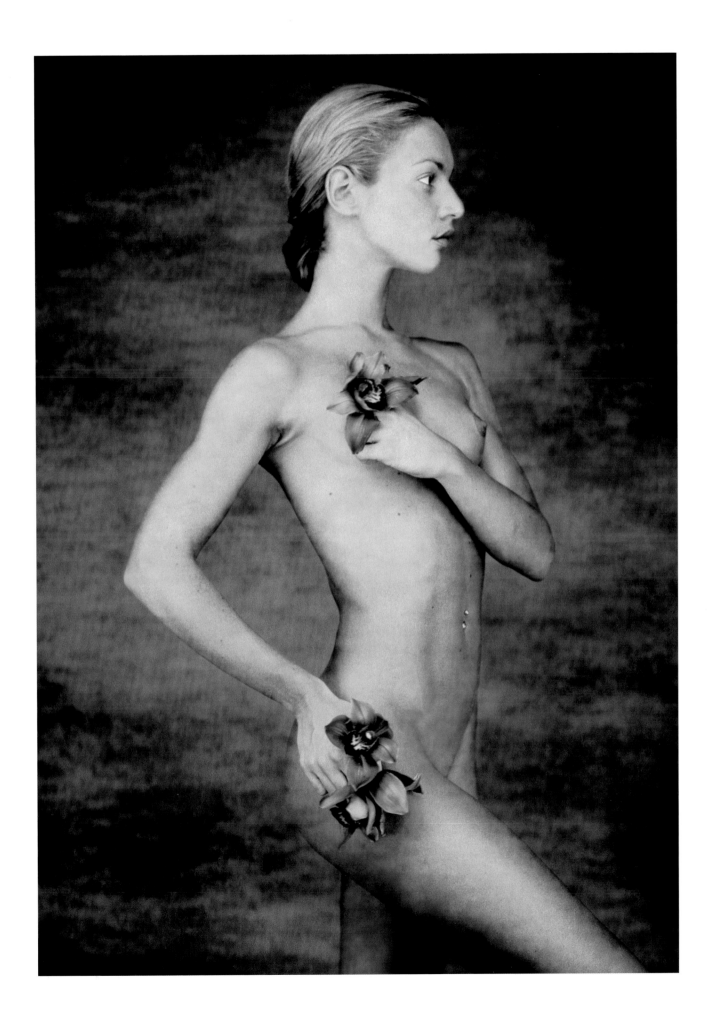

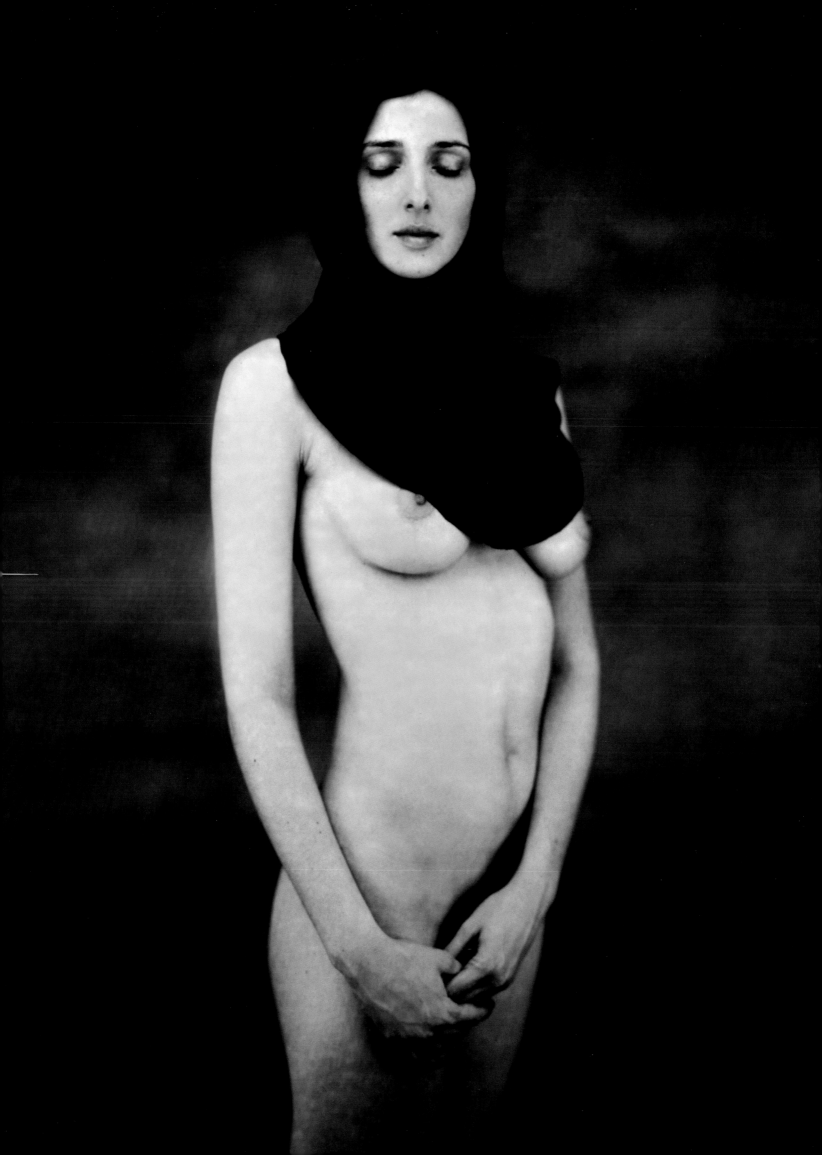

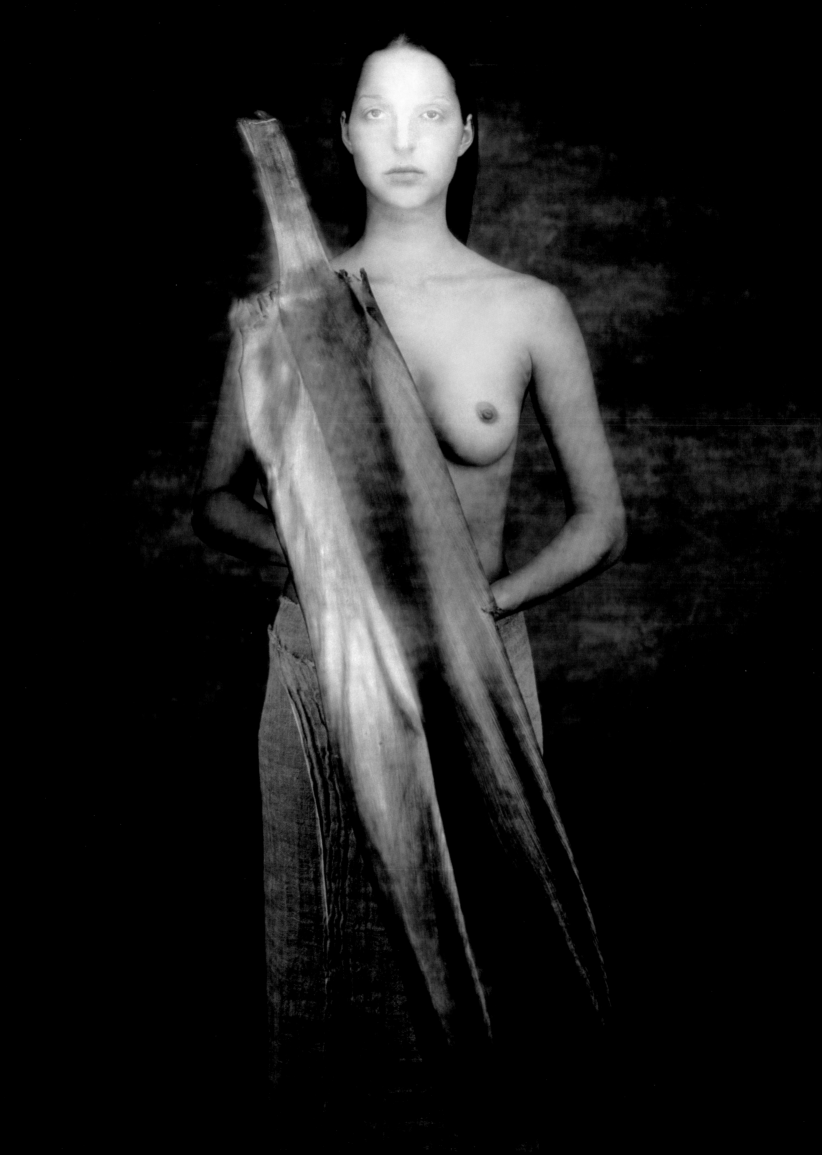

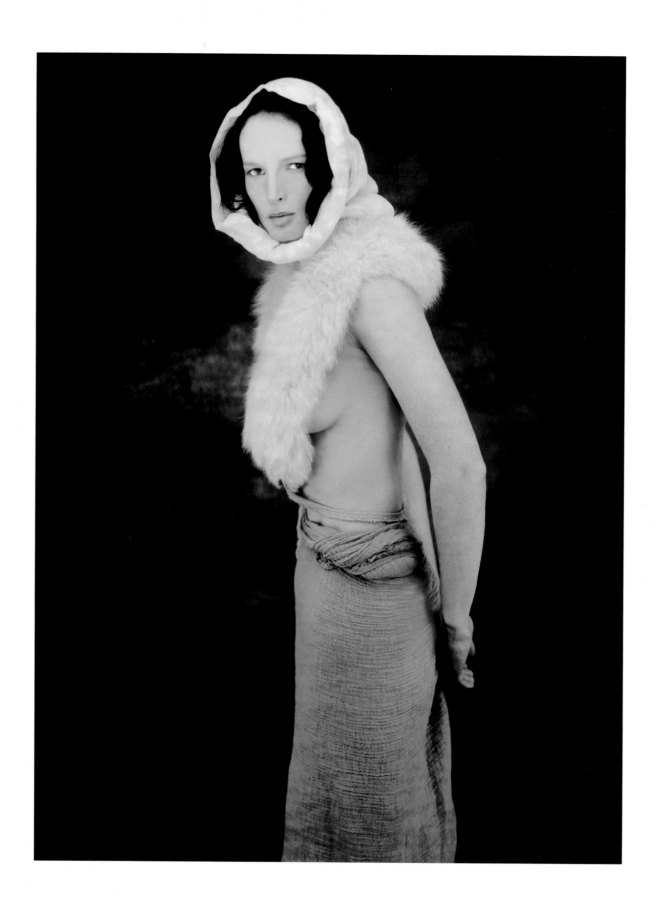

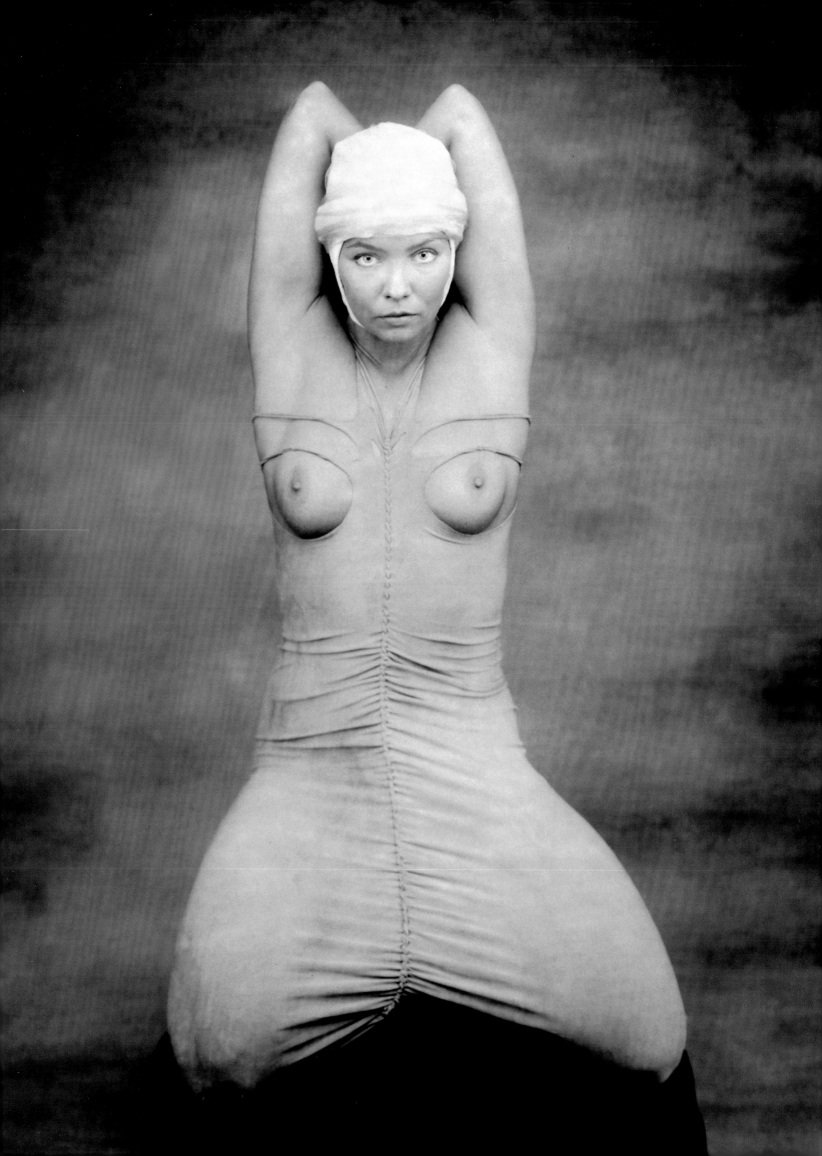

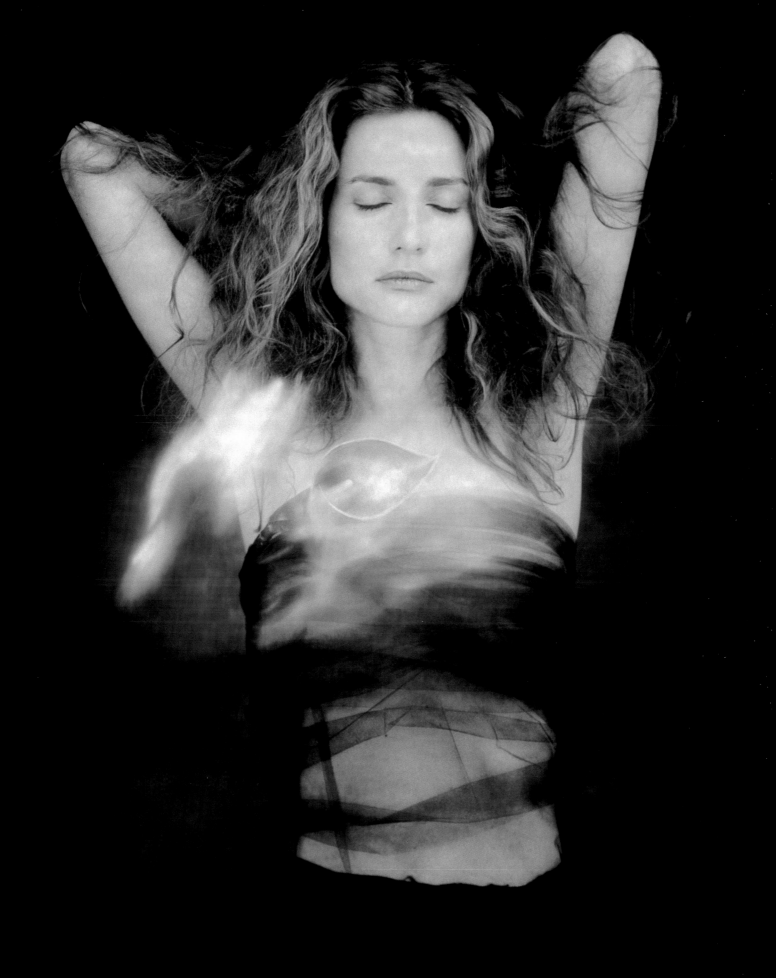

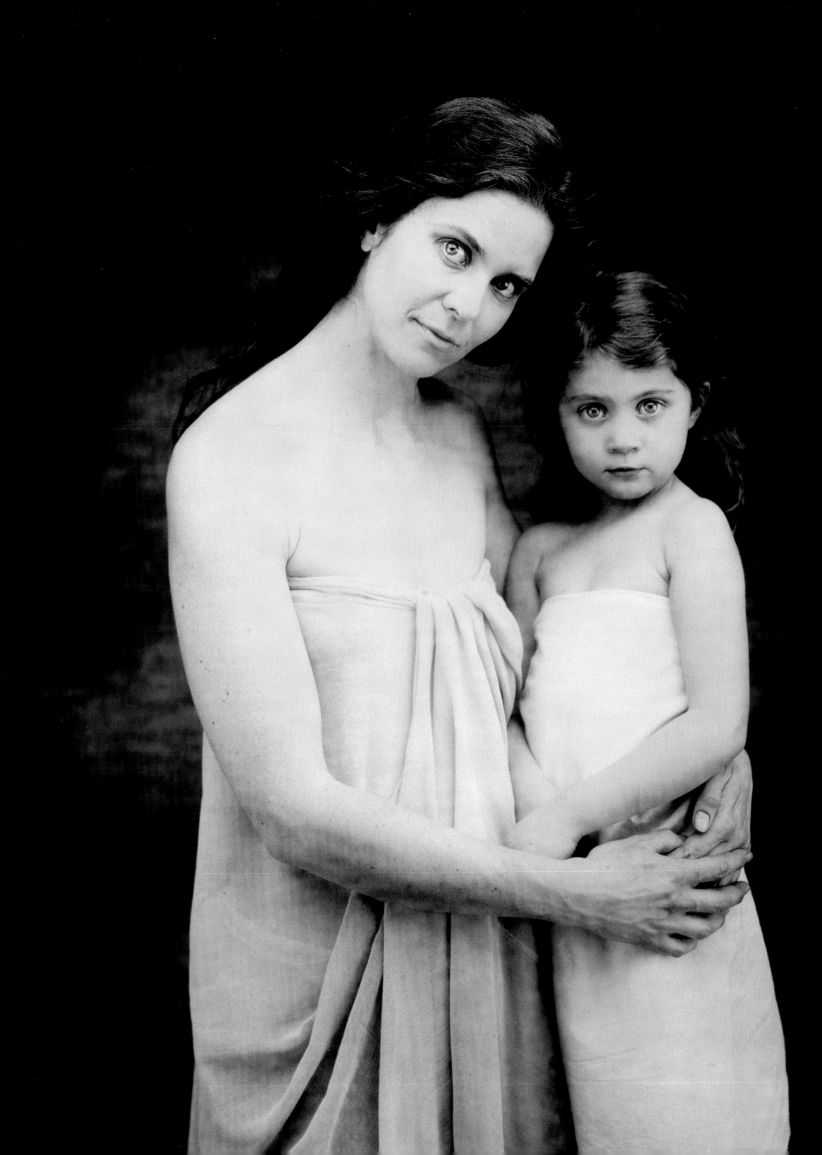

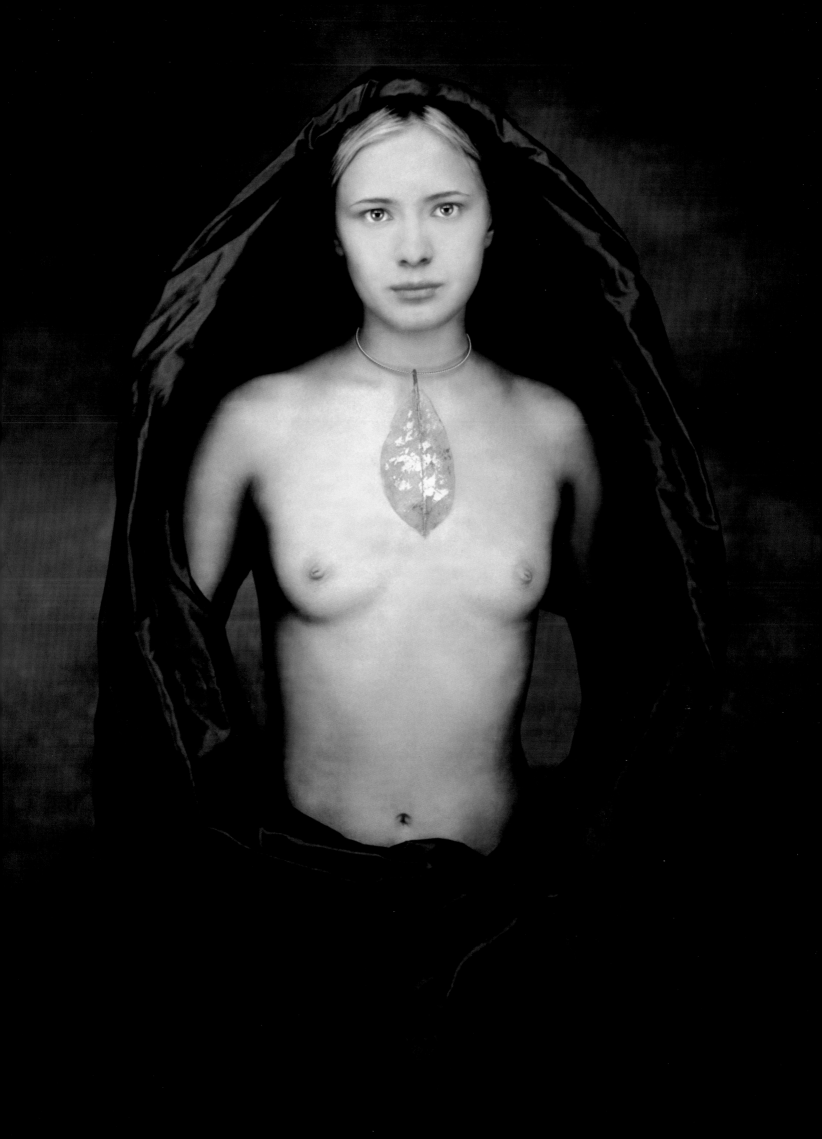

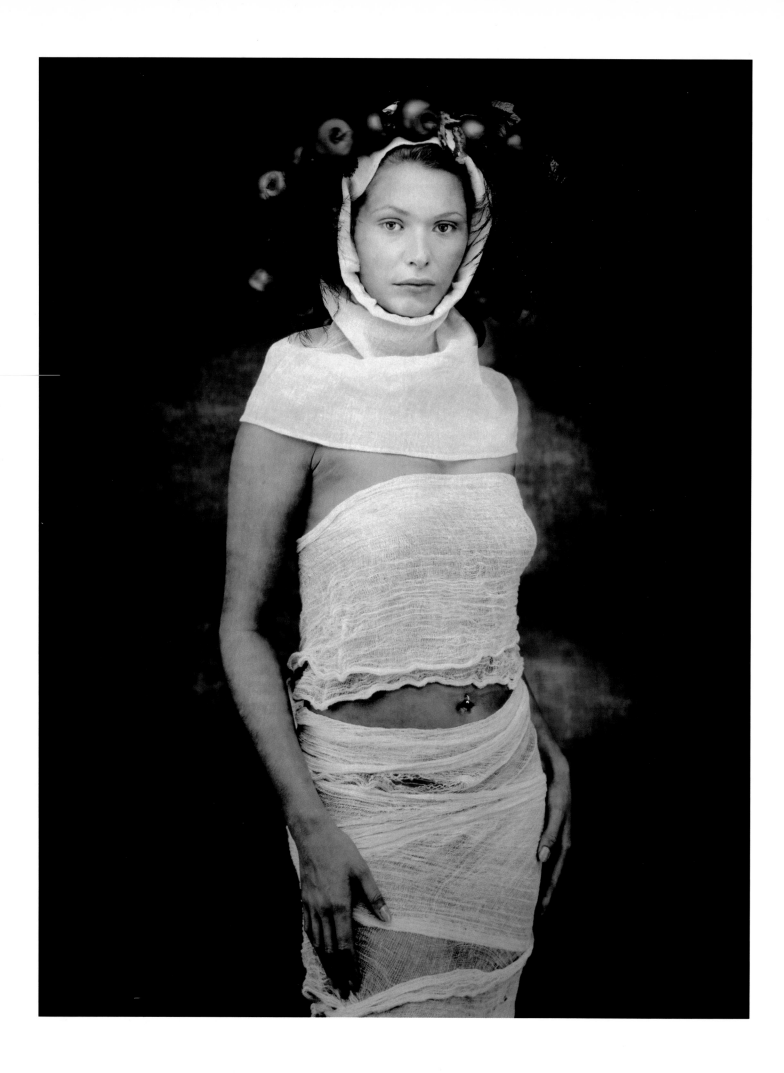

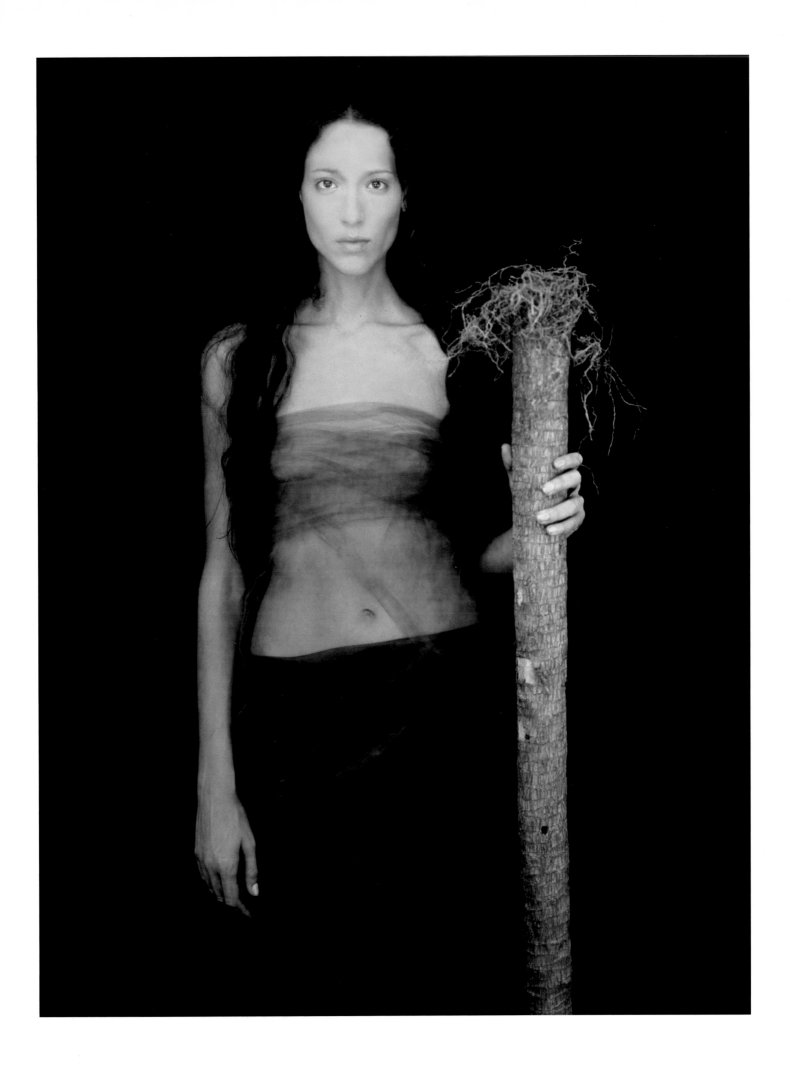

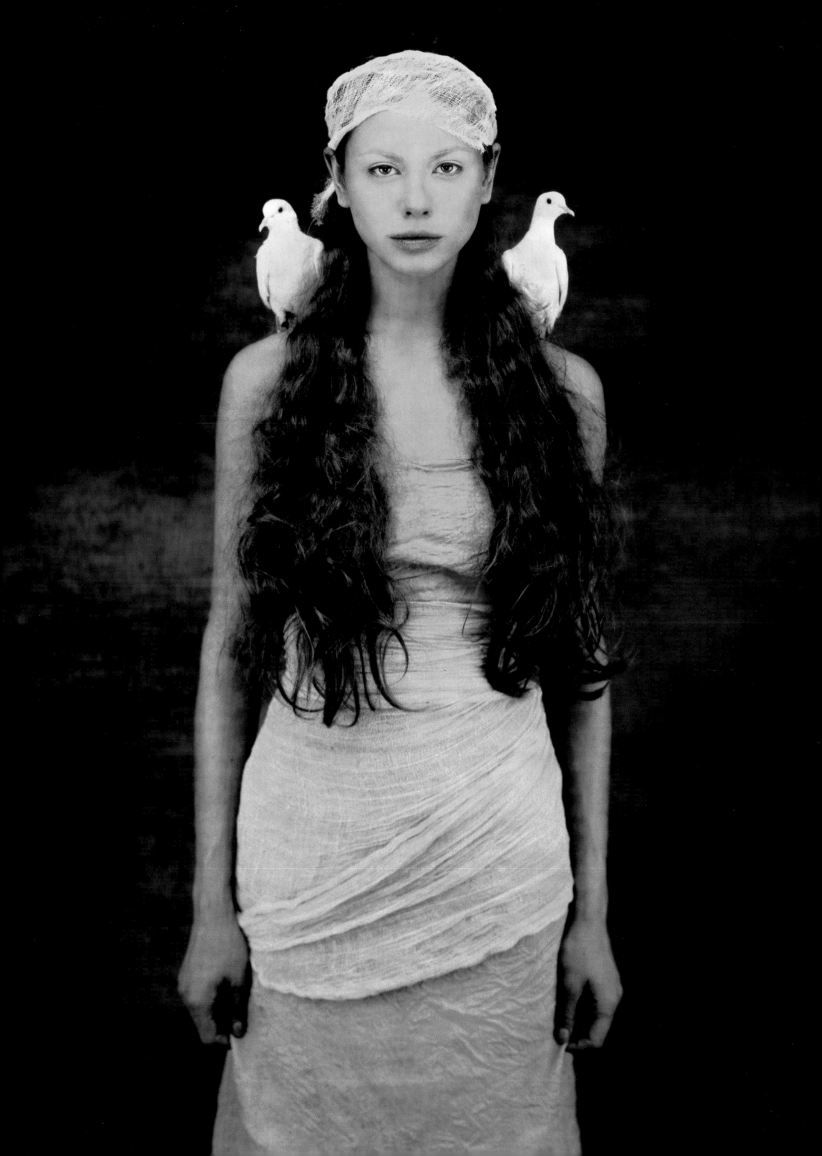

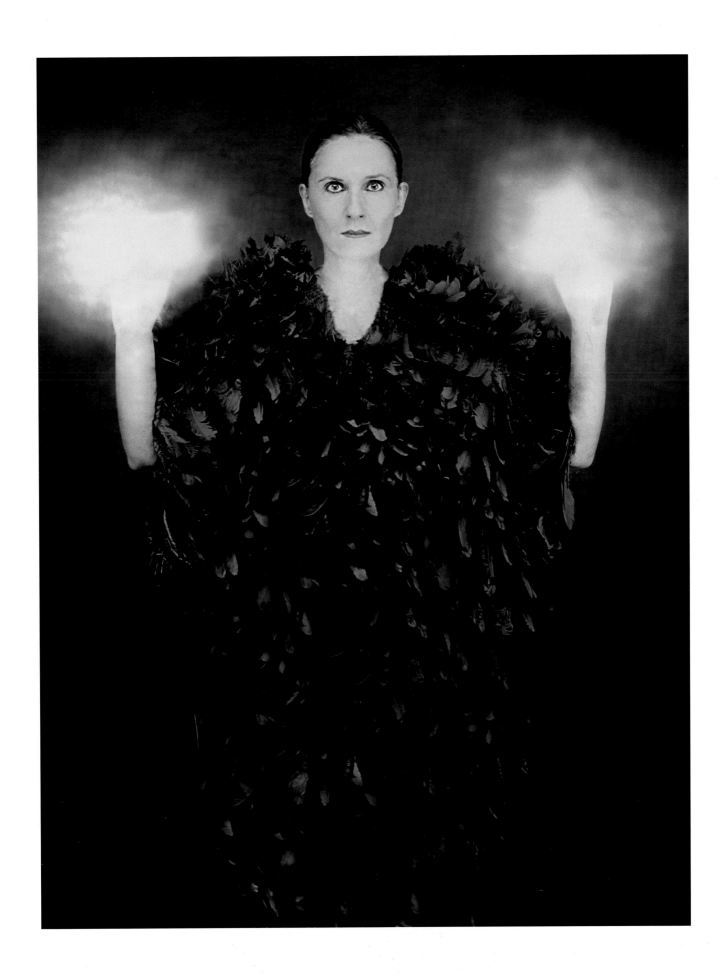

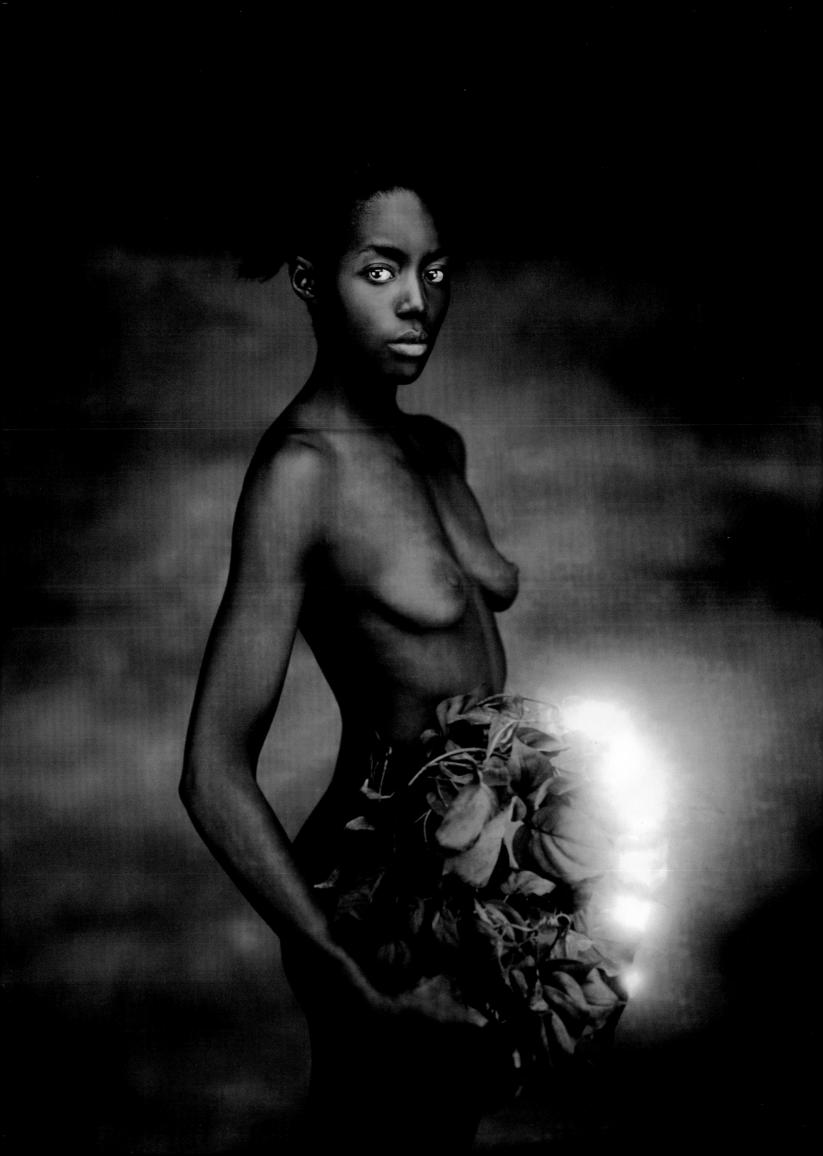

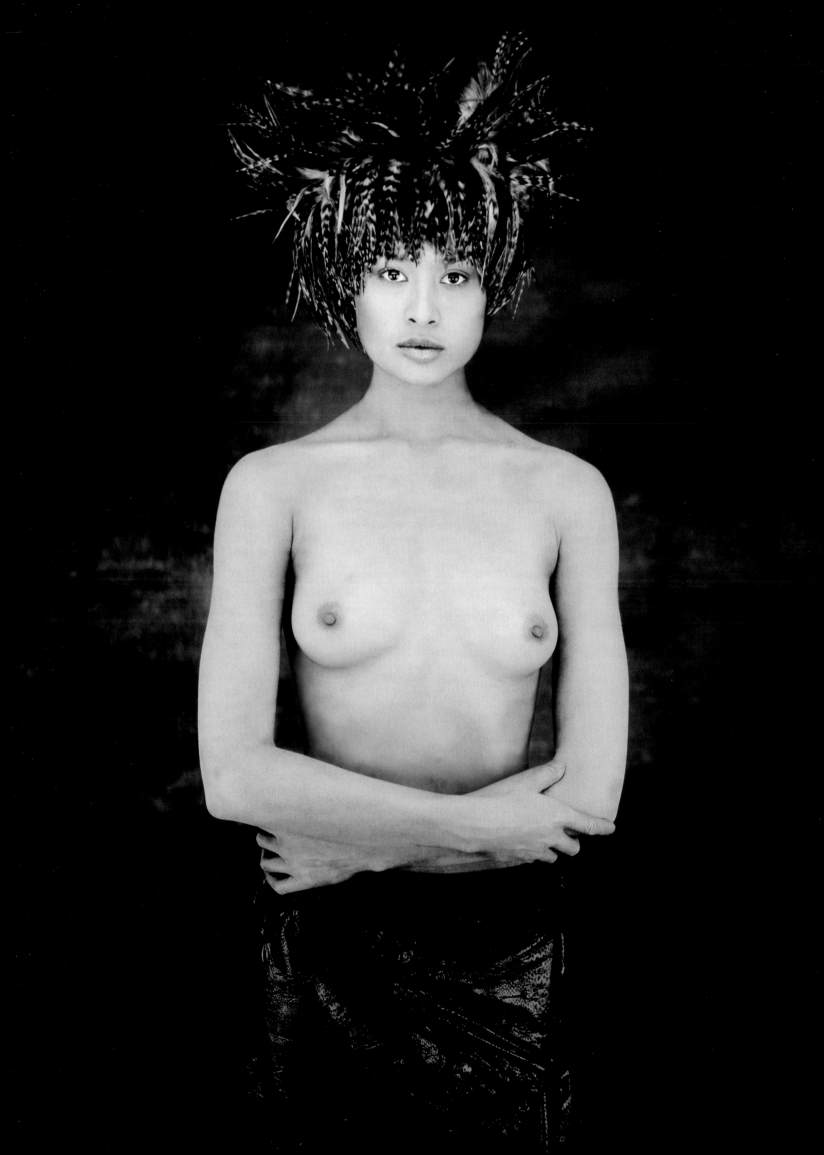

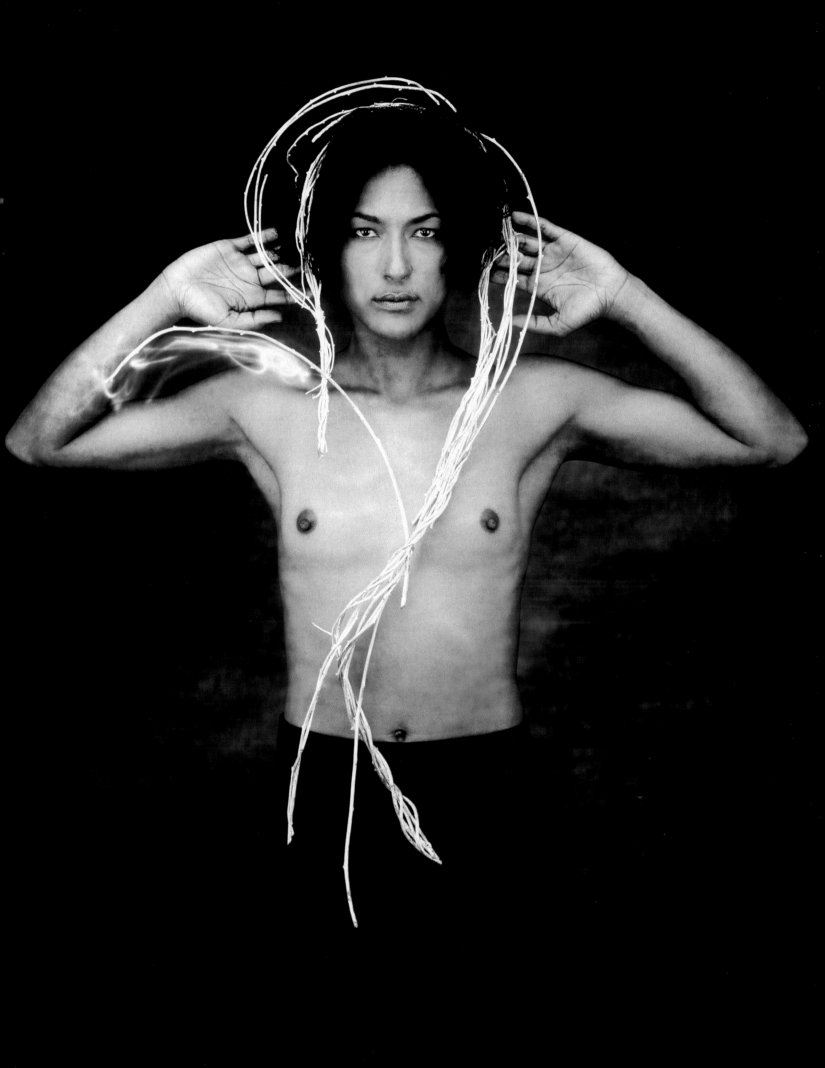

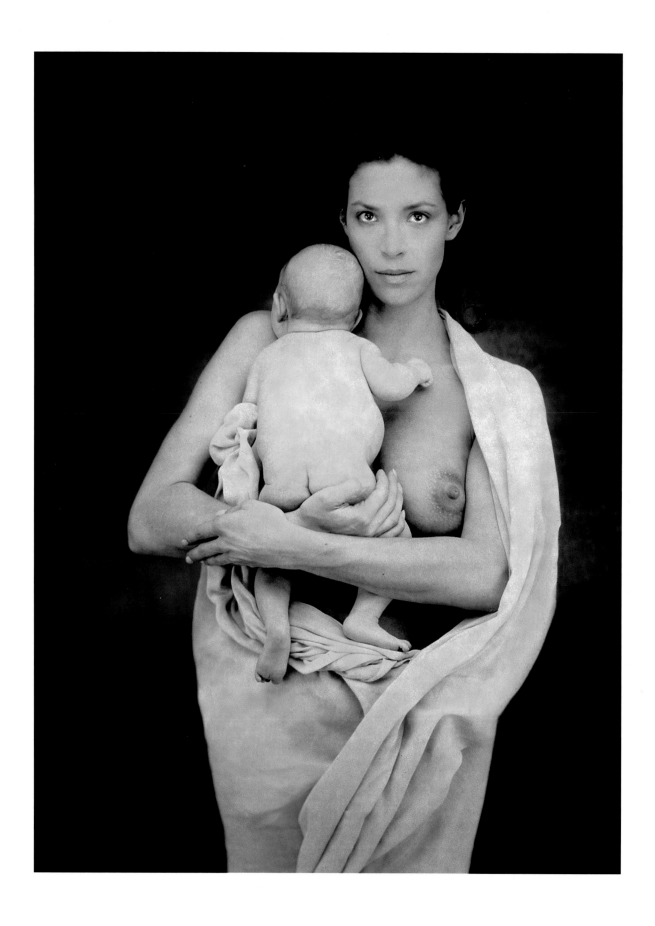

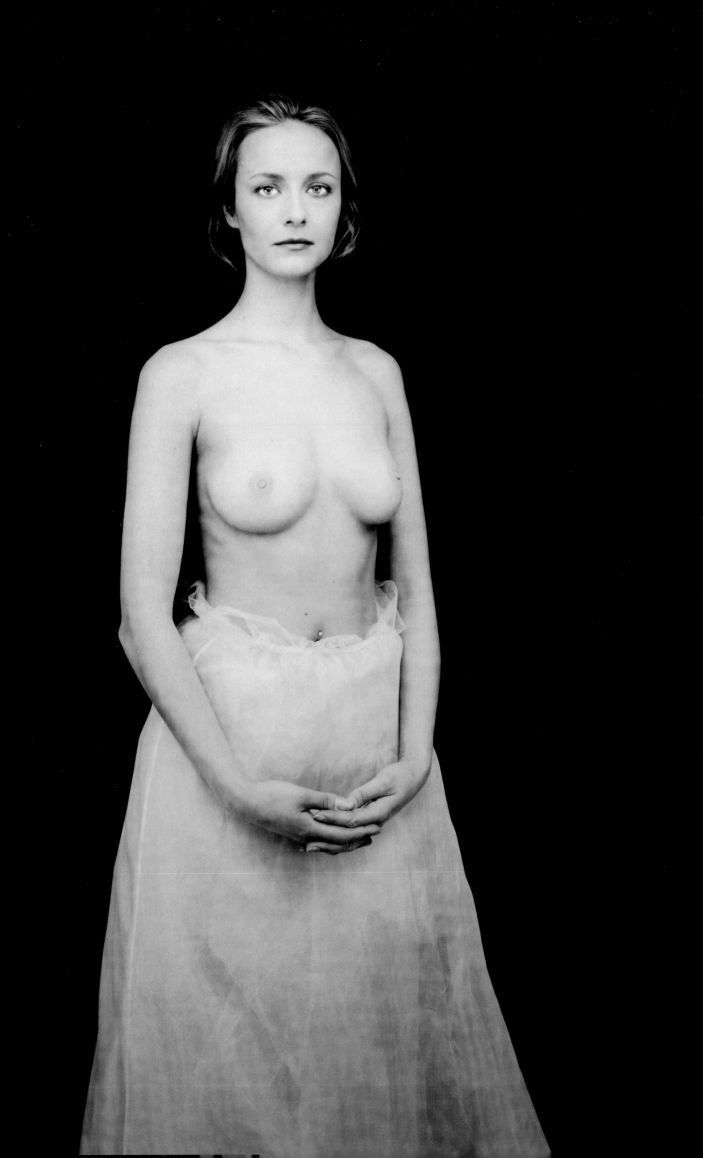

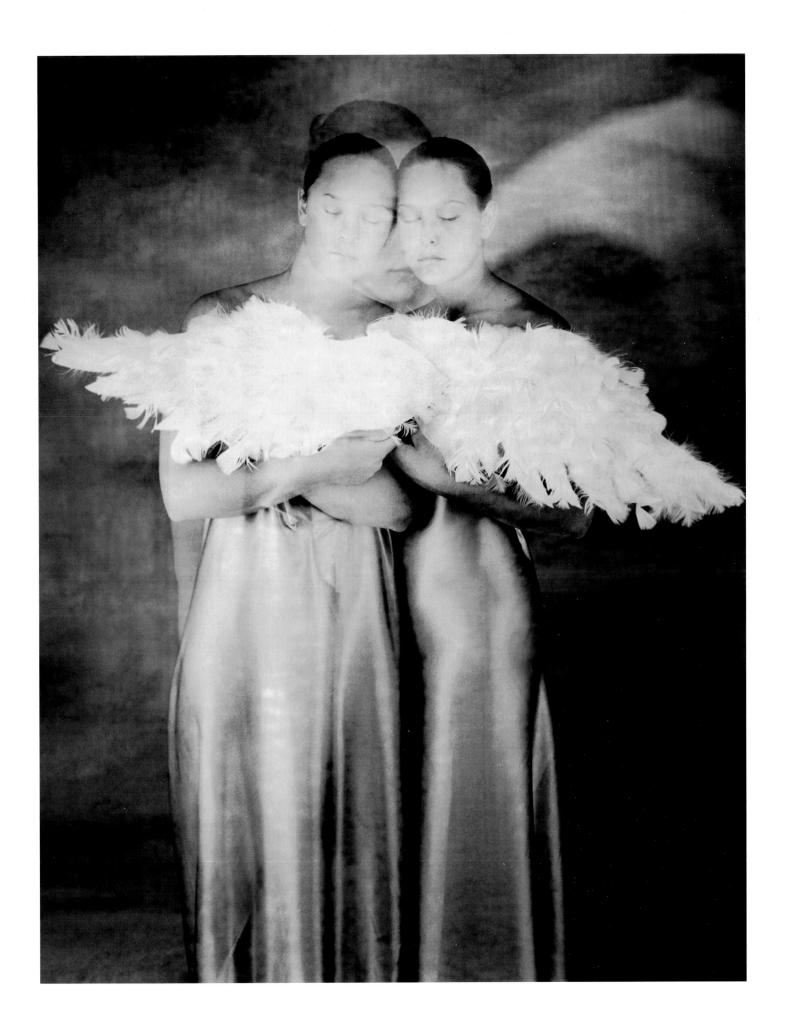

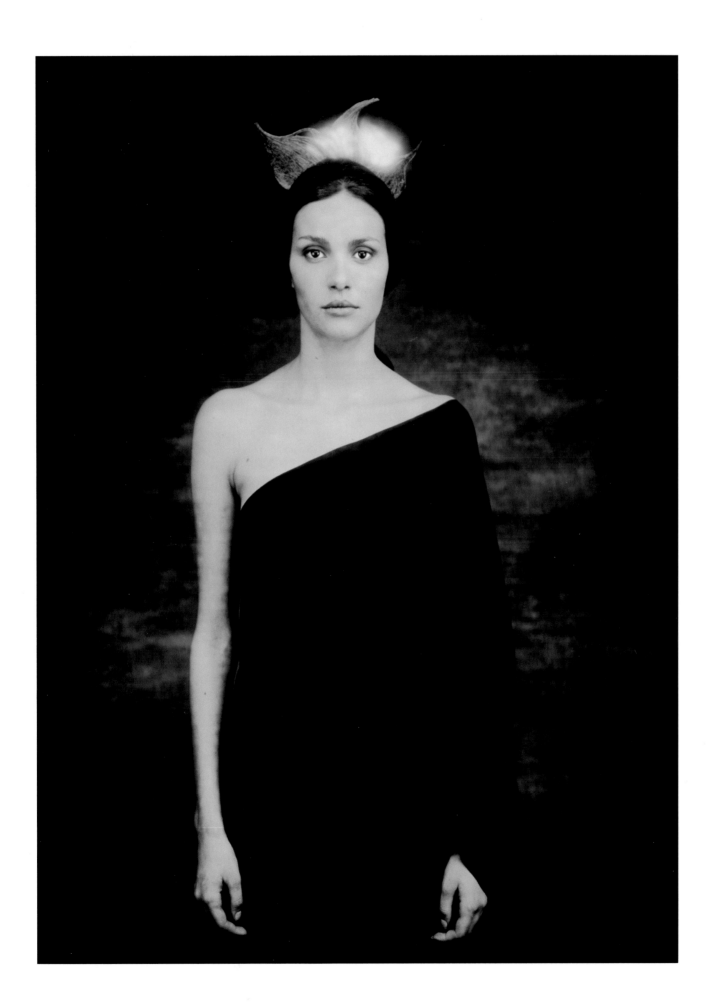

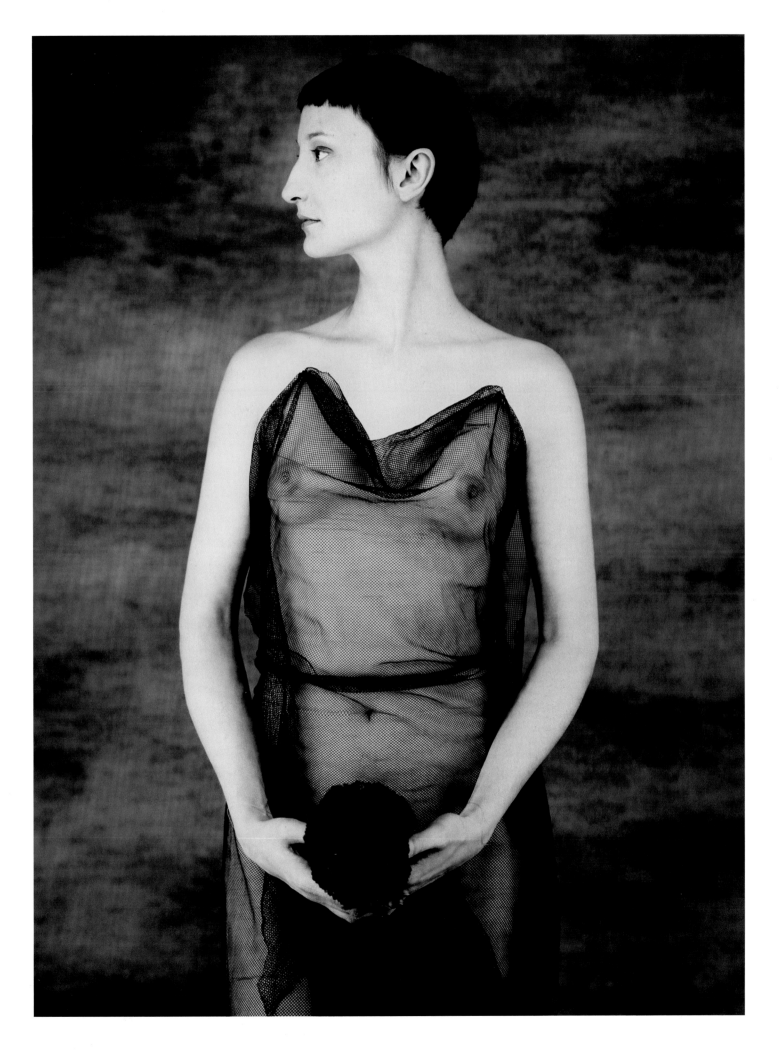

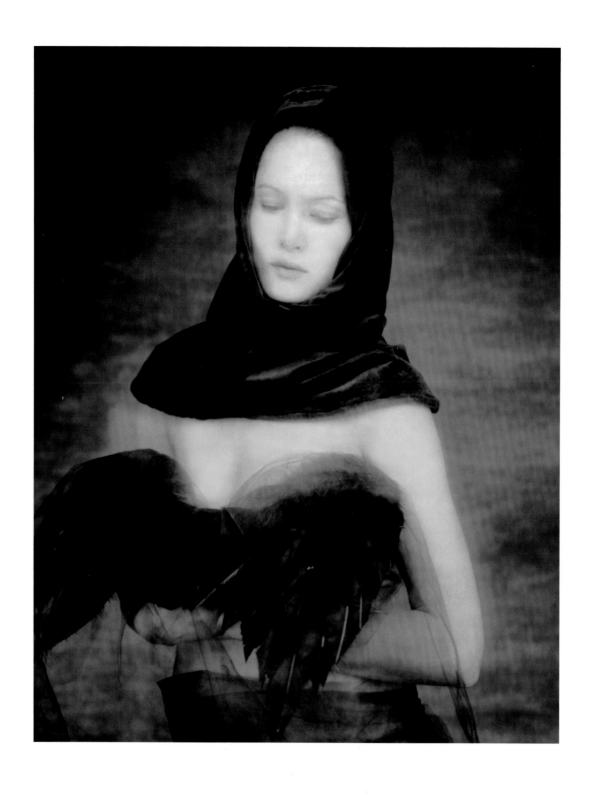

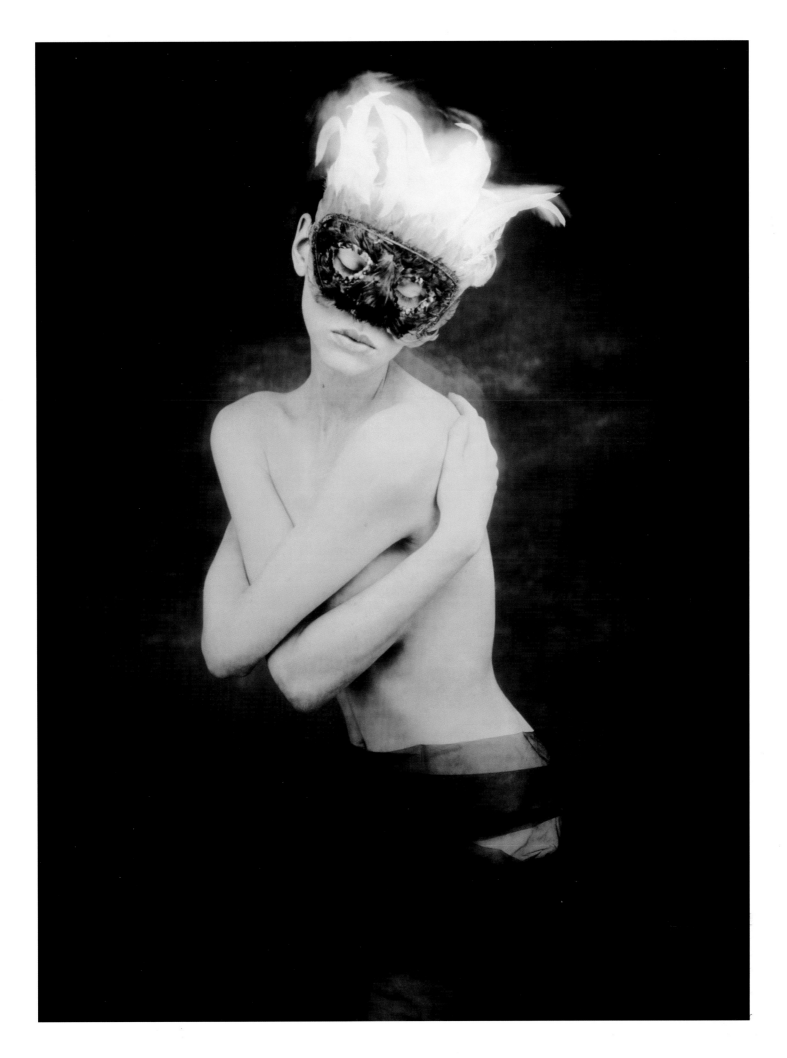

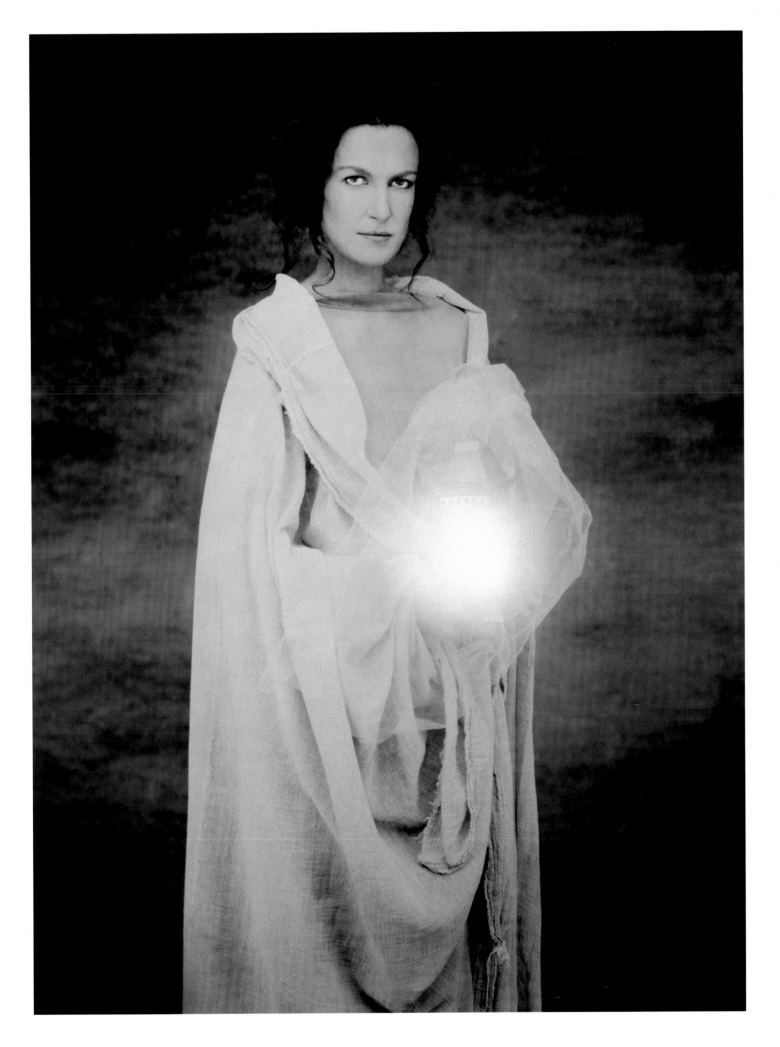

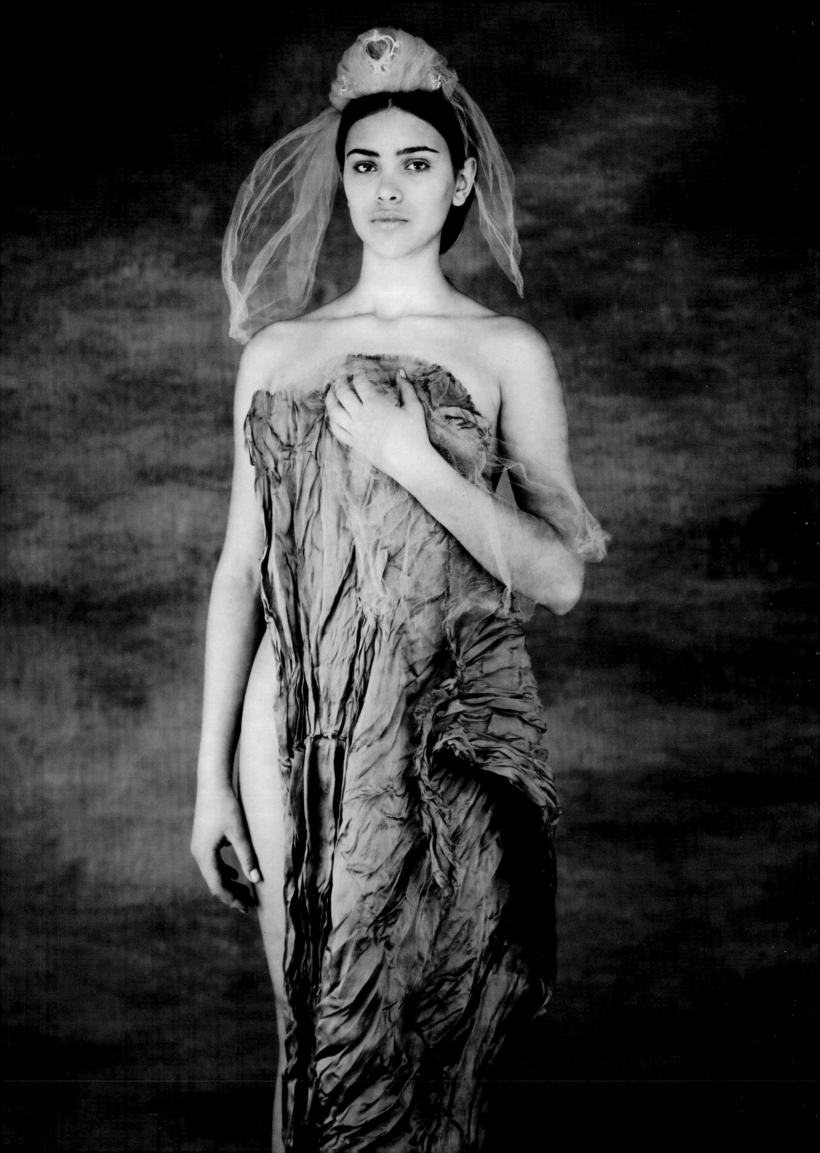

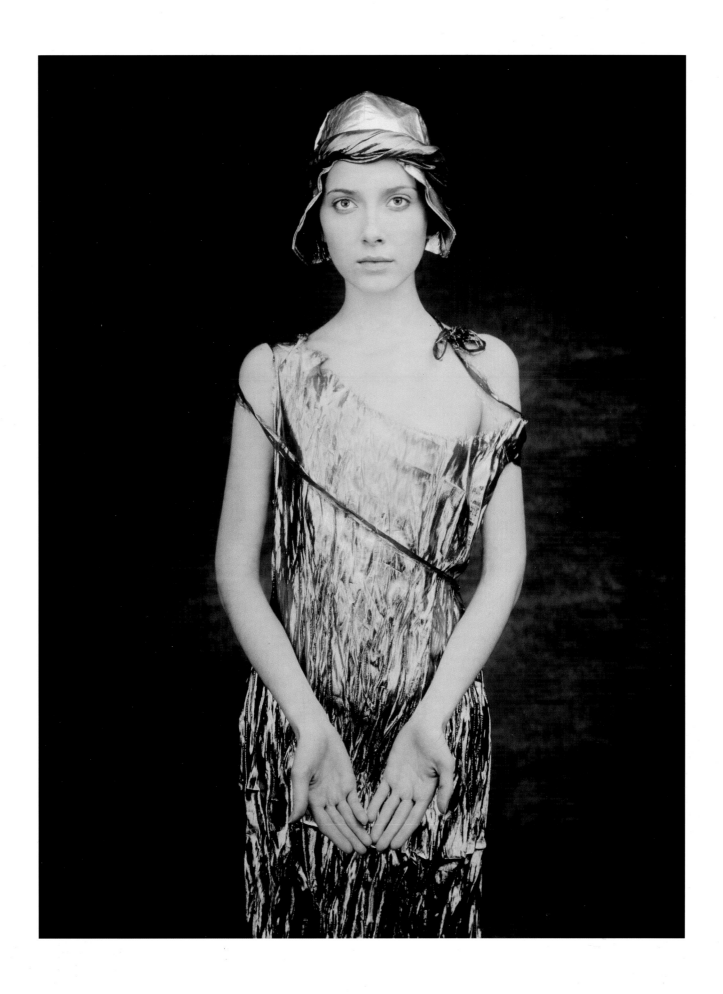

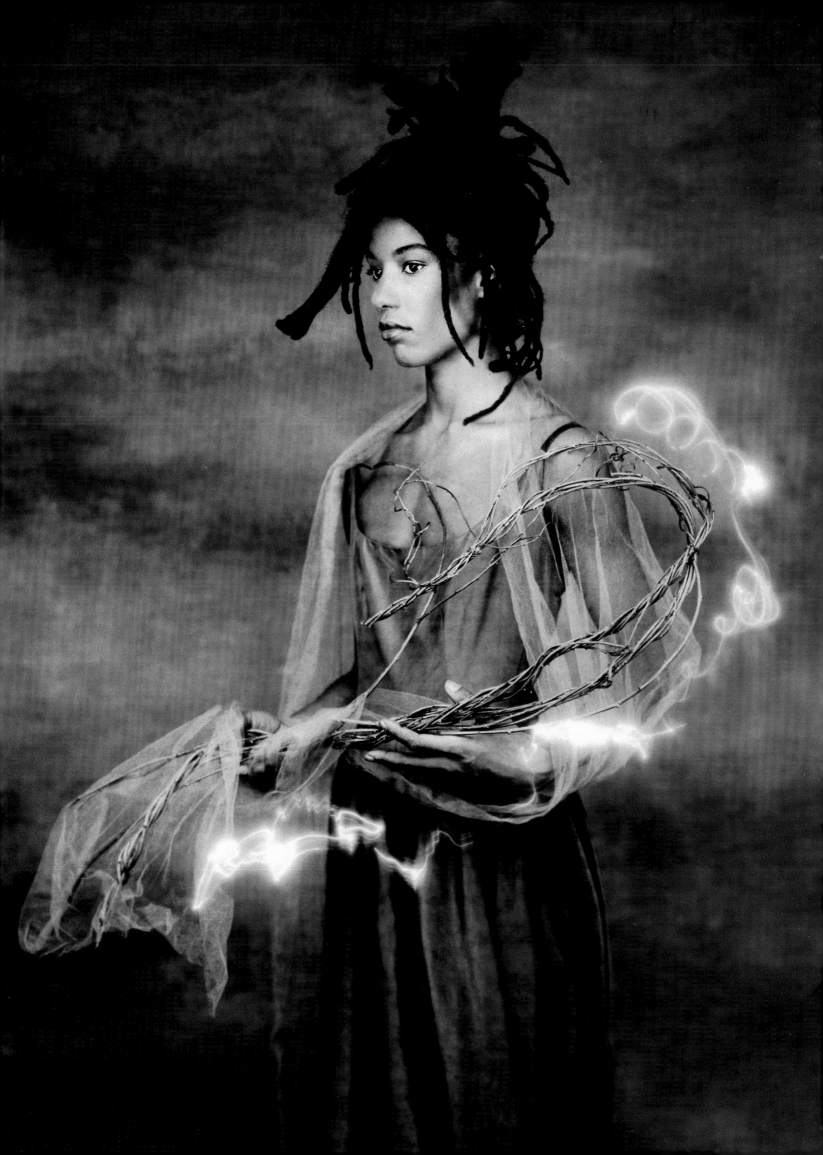

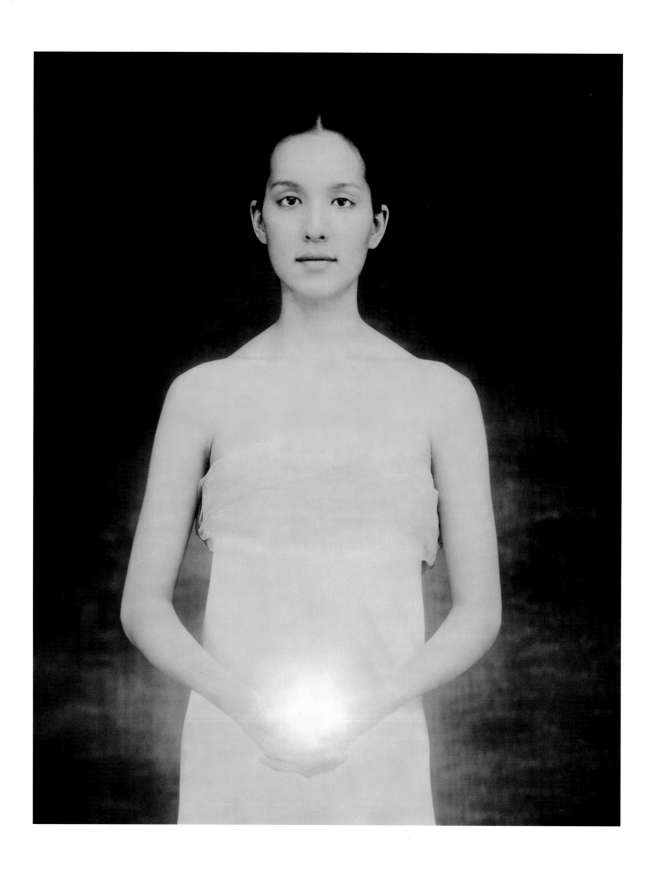

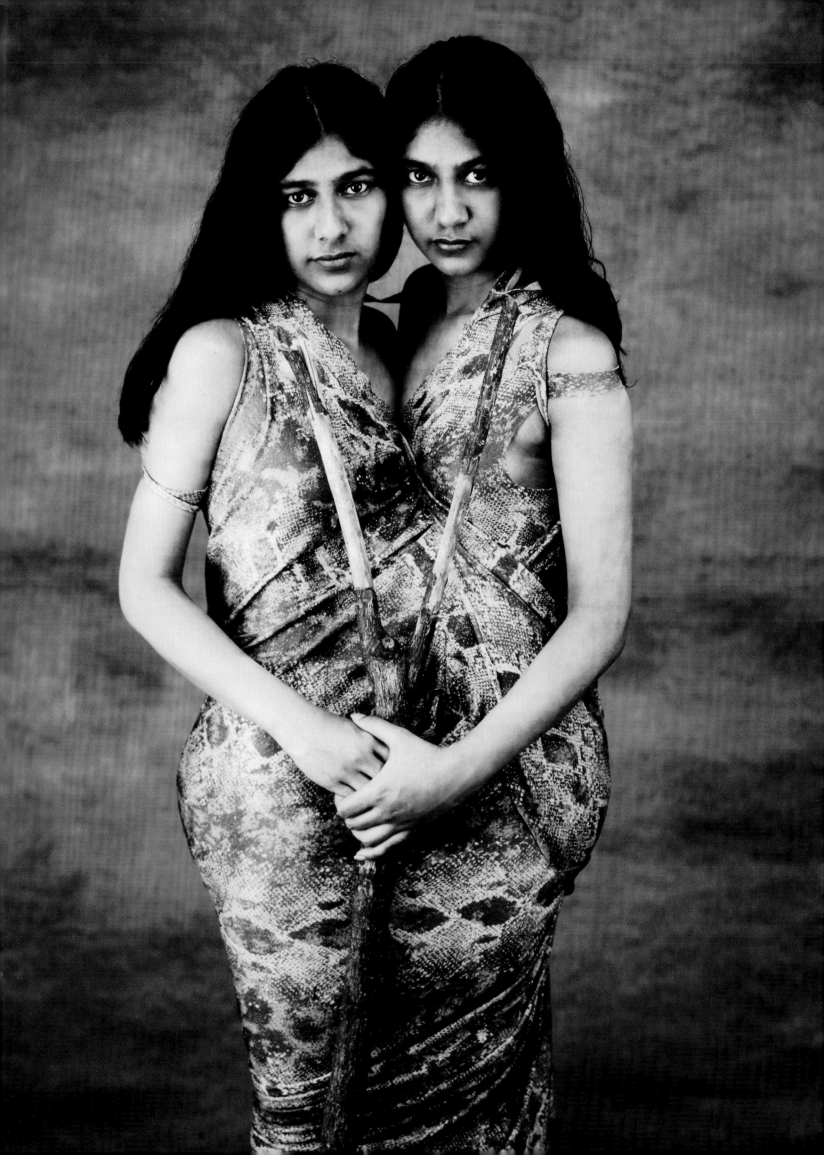

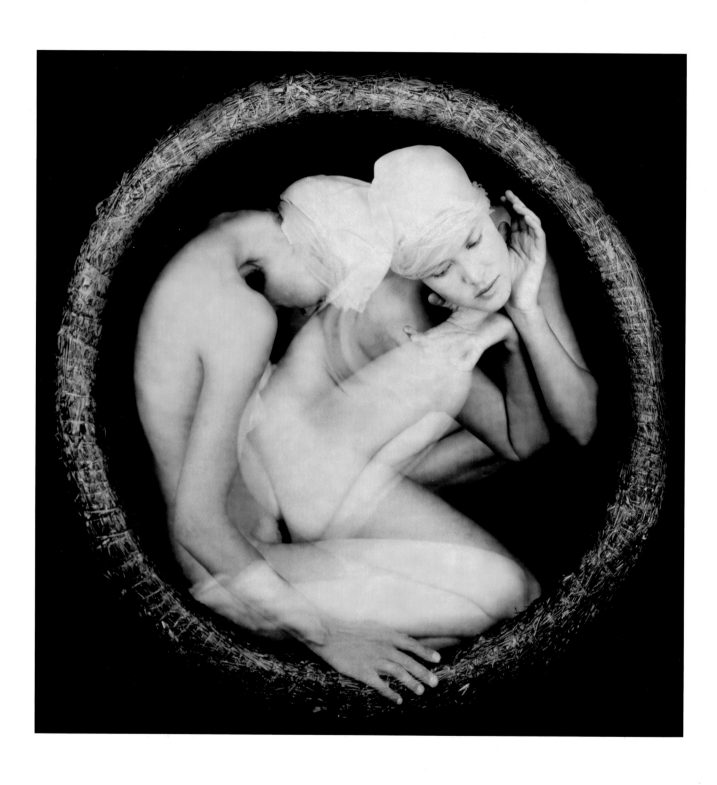

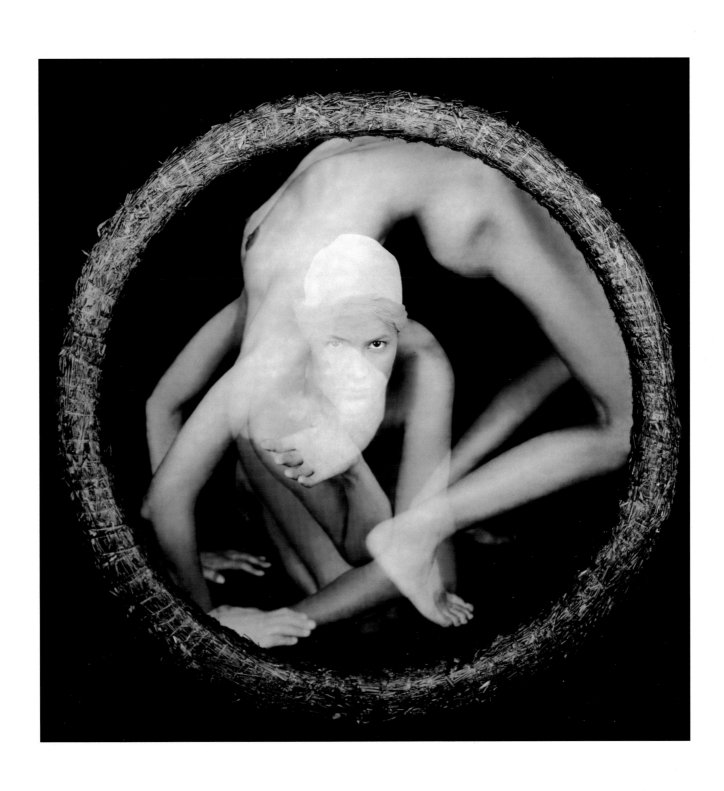

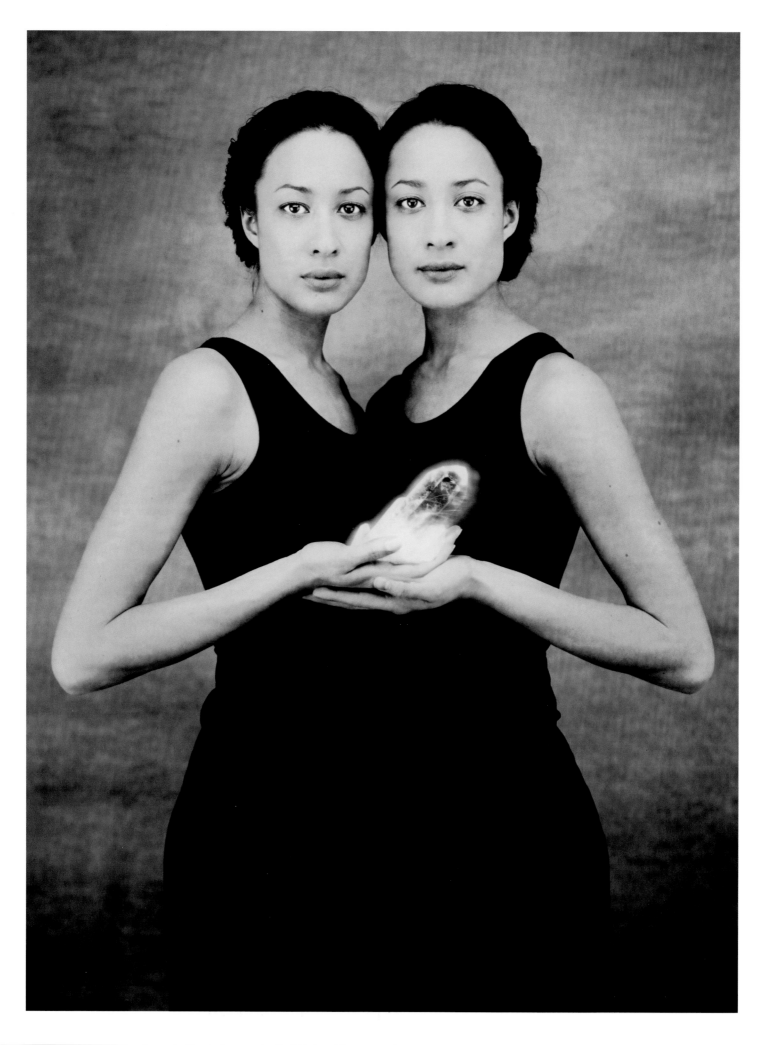

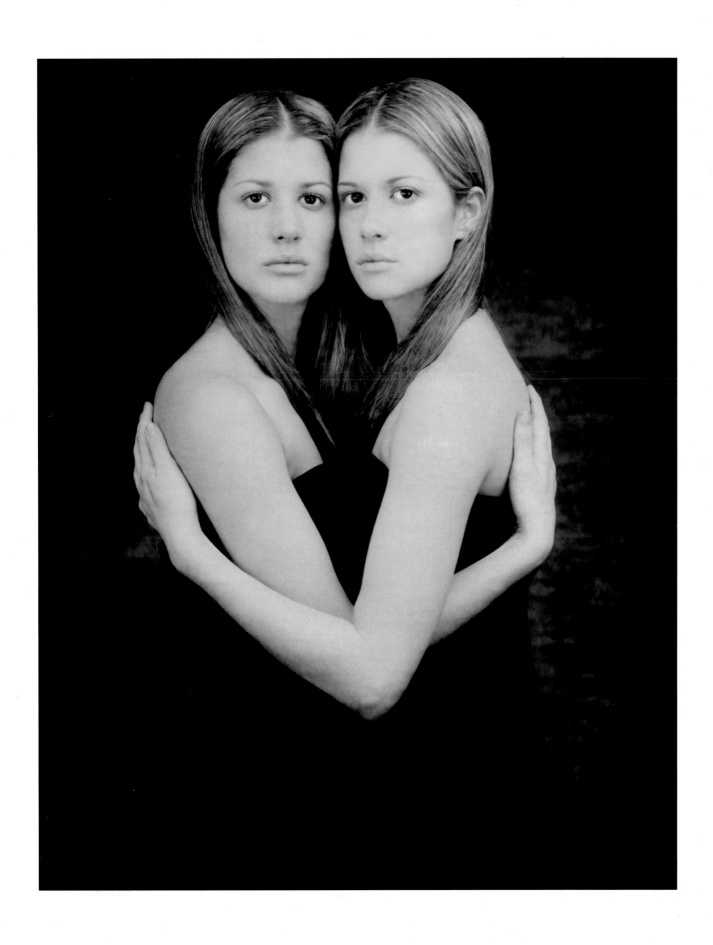

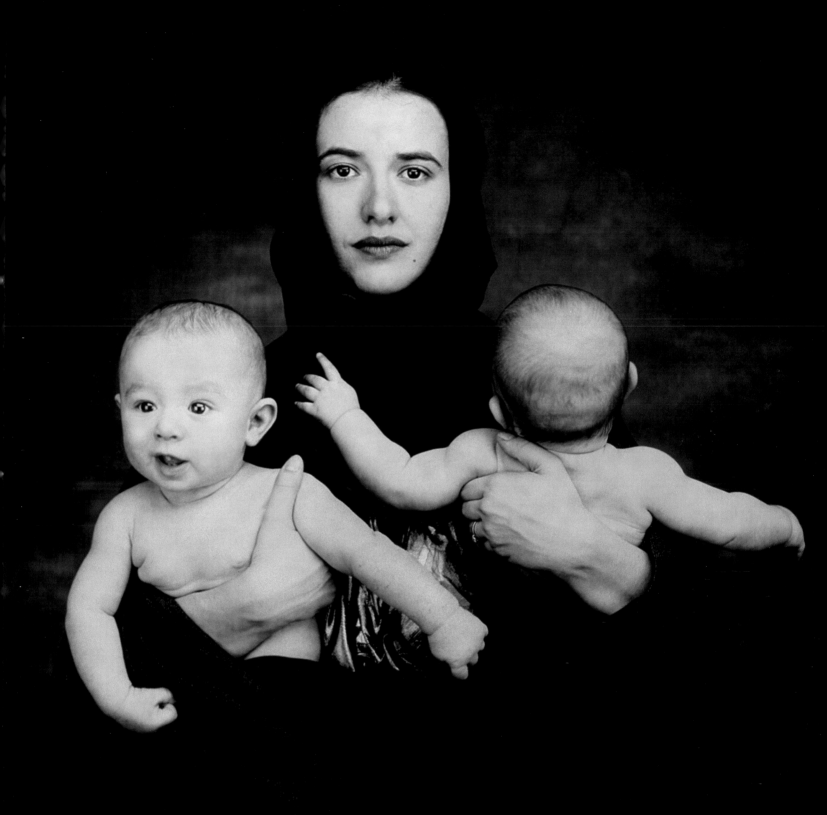

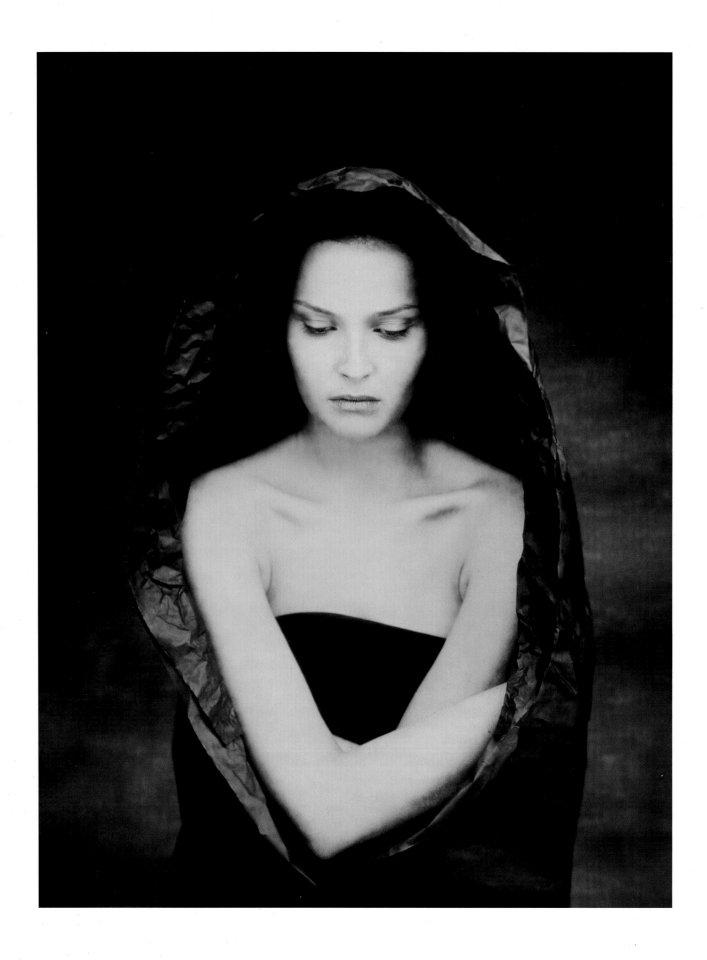

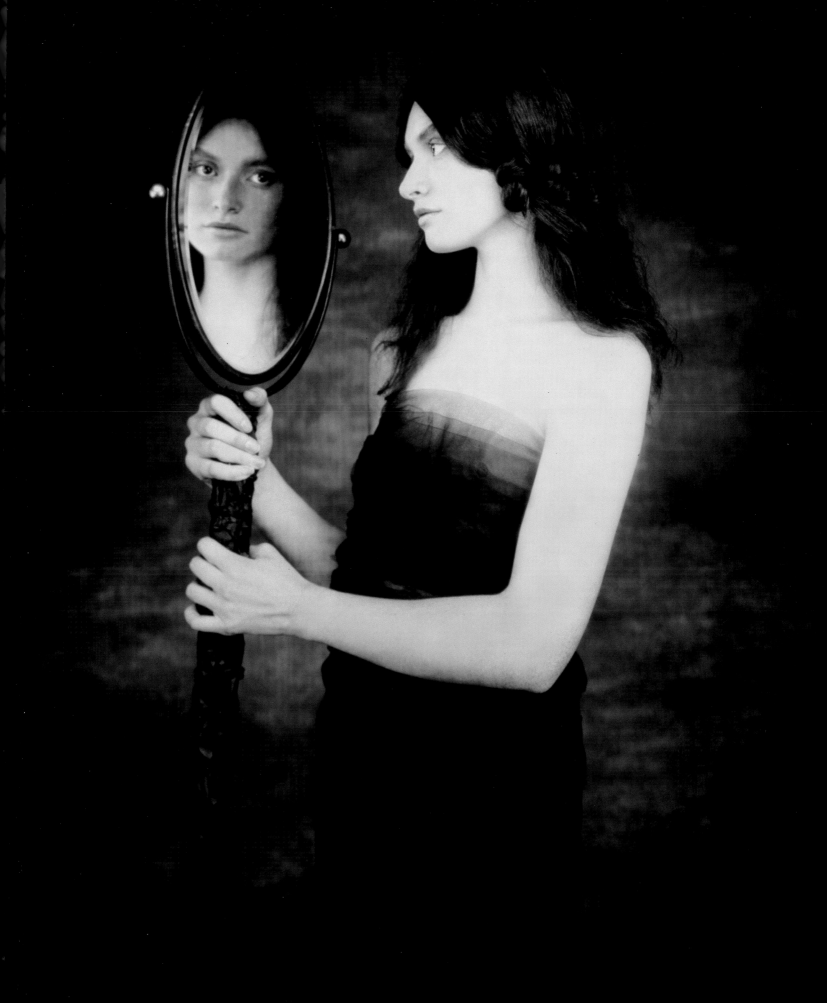

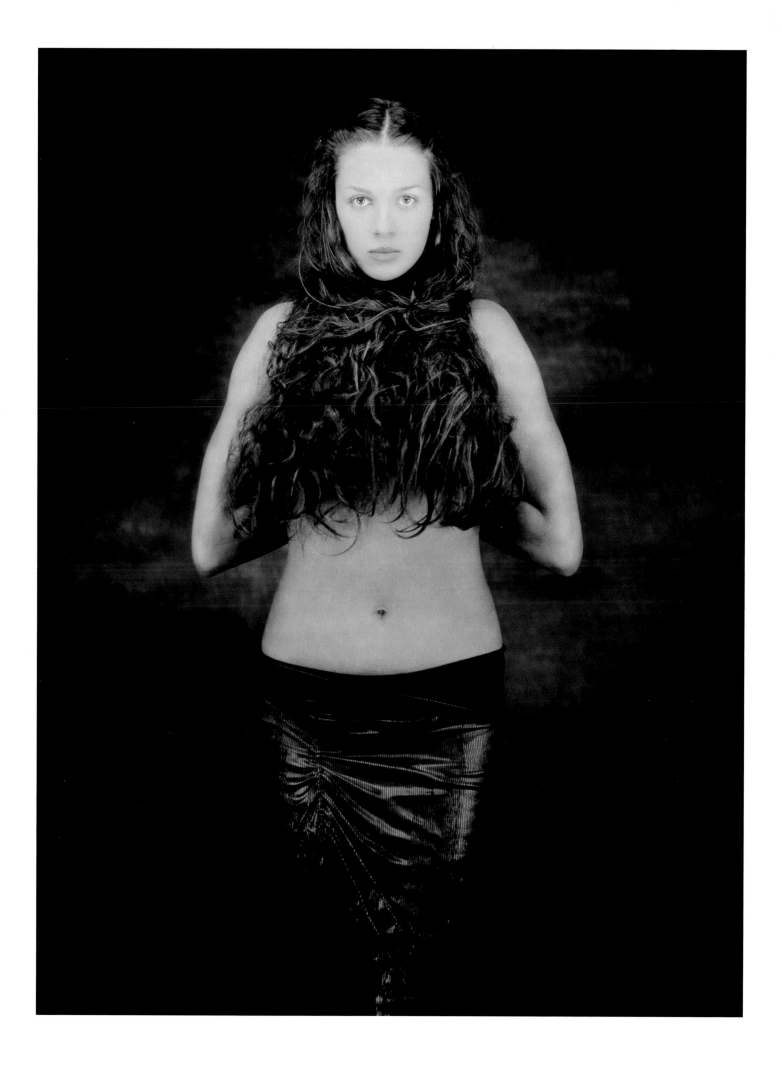

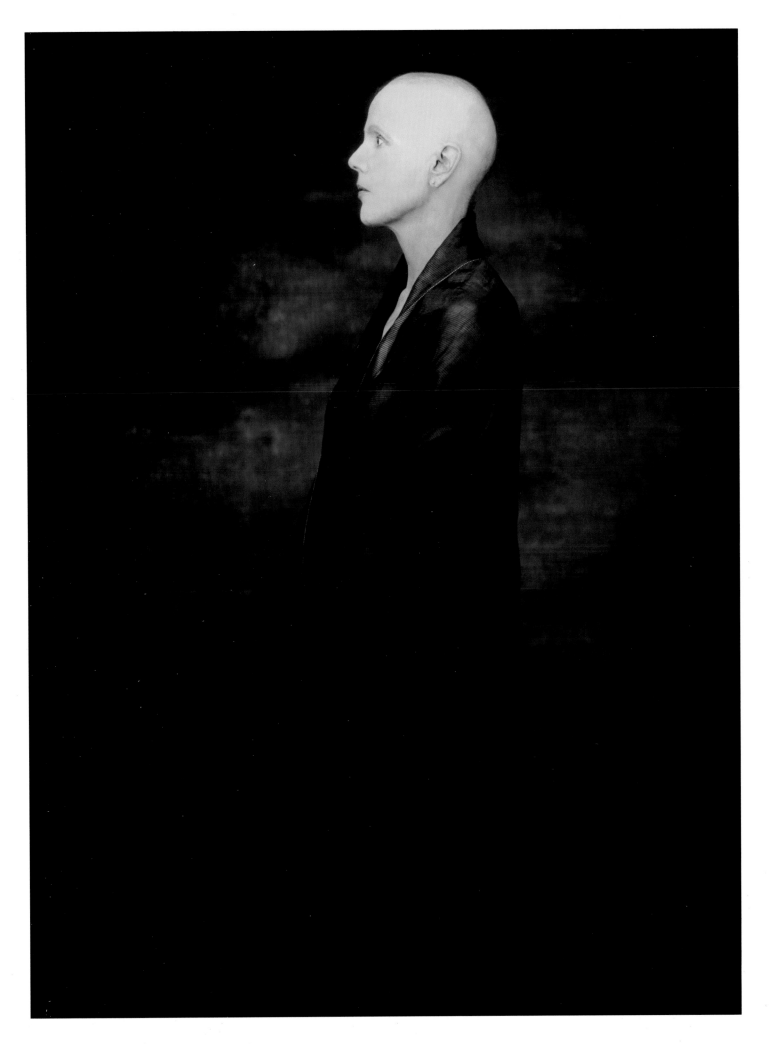

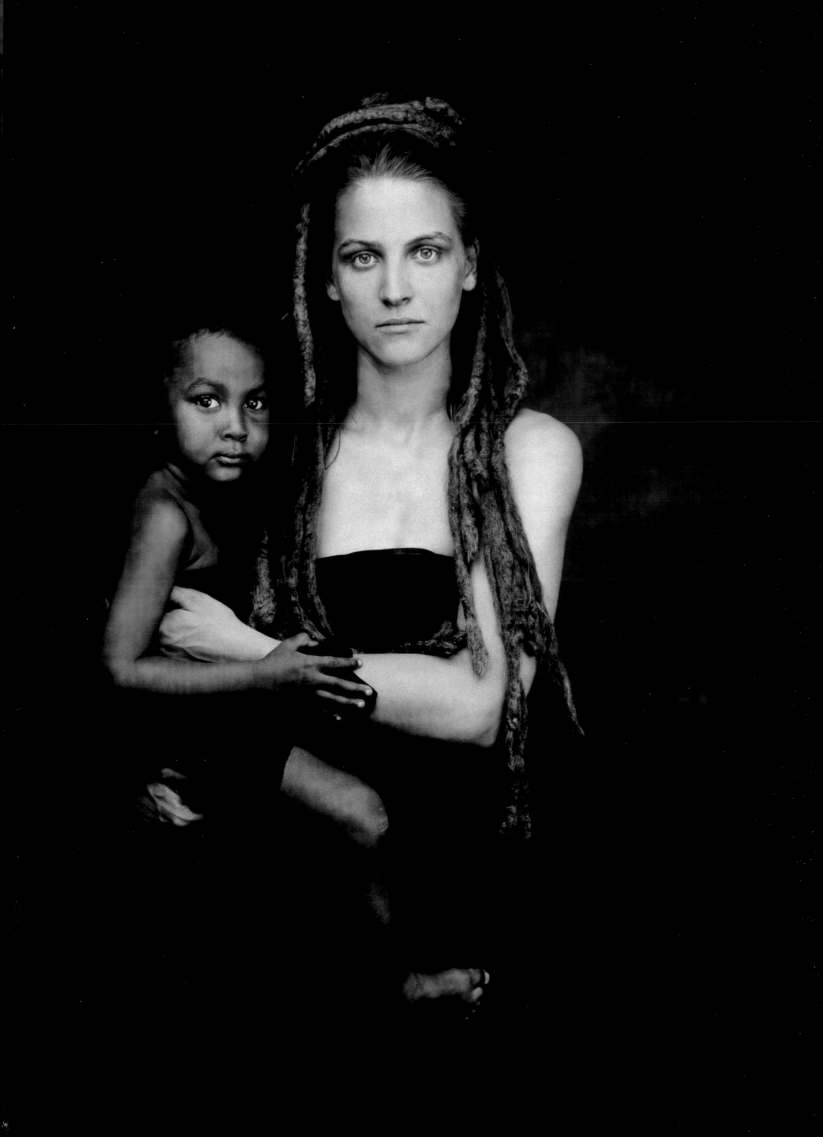

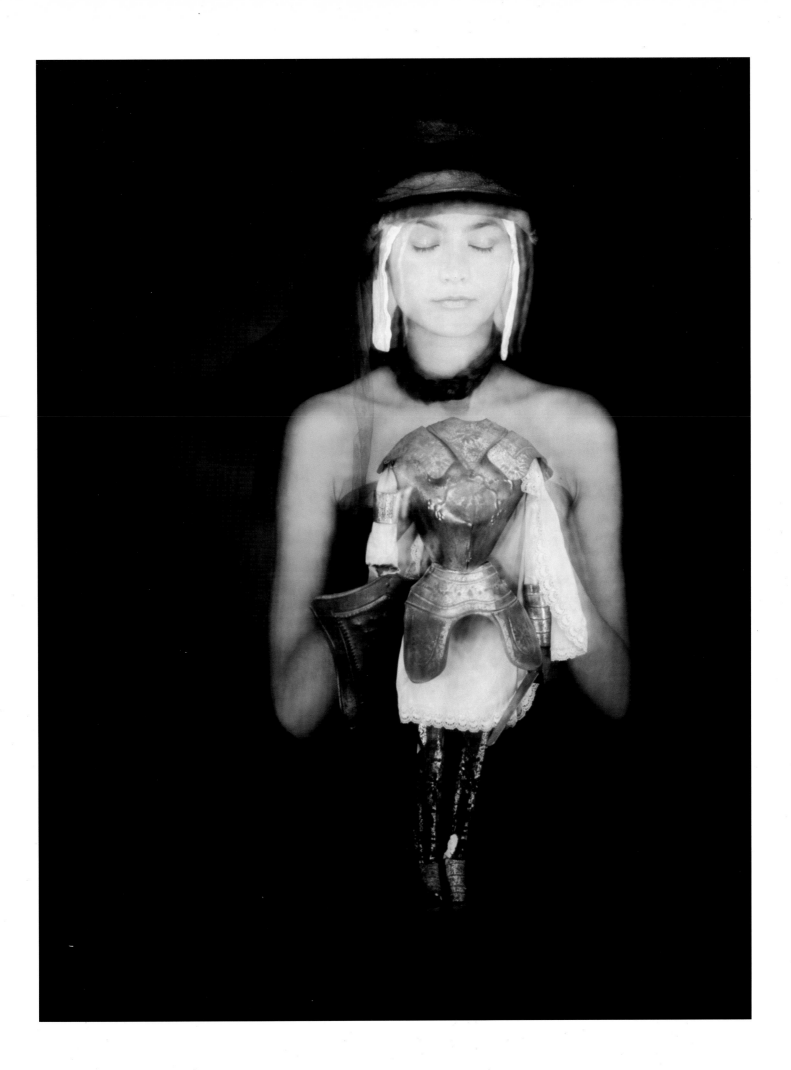

PLATES

Frontispiece: Melinda, United States; page 11: Nina Z., Russia; 12: Sheryl, United States; 13: Sheryl and Sef, United States; 15: Rebekka, Finland; 17: Marisa, United States; 19: Patricia, United States; 21: Sun, United States; 22: Heather and Erin, United States; 23: Heather and Erin, United States; 25: Nina K., Poland; 26: Hoya, Korea; 27: Coralie, United States; 29: Nina B., Germany; 31: Larissa D., Slovenia; 33: Katia, Russia; 34: Heather and Erin, United States; 35: Heather and Erin, United States; 37: Laura and Isaac, United States; 39: April, United States; 41: Melisa, New Zealand; 43: Michele, United States; 45: Lesah Ann, United States; 46: Diane and Jodie, United States; 47: Ayla, United States; 48: Virginie, France; 49: Virginie and Kimani, France; 51: Carol, France; 53: Yael, Israel; 55: Coralie, United States; 56: Rachel, United Kingdom; 57: Larissa K., Russia; 59: Marie-Claude, Canada; 61: Susan and Basia Tess, United States; 63: Nadya, Russia; 64: Valerie, France; 65: Virginia, Spain; 67: Dasha, Russia; 69: Joyce, United States; 71: Agola, Kenya; 73: Jasmin, Australia; 75: Andrea, United States; 76: Amy and Kiera, United States; 77: Nina B., Germany; 79: Jenny and Julie, United States; 81: Katarina, Croatia; 83: Bernadette, Canada; 84: Sun, United States; 85: Marisa, United States; 87: Felicitas, United States; 88: Alina, Romania; 89: Aaron, United States; 91: Lisa, United States; 92: Christina, United States; 93: Marukh and Shahrukh, India; 94: Sun, United States; 95: Sun, United States; 96: Kimberly and Christen, United States; 97: Lindsay and Amanda, United States; 99: Bless, Gabriel, and Hannah, United States; 100: Linda, Hungary; 101: Jessica, United States; 103: Elena, Ukraine; 105: Marcia, United States; 107: Katherine and Kudyba, United States/Senegal; 109: Margarita, Russia; 111: Polina, Russia; 112: Sun, United States

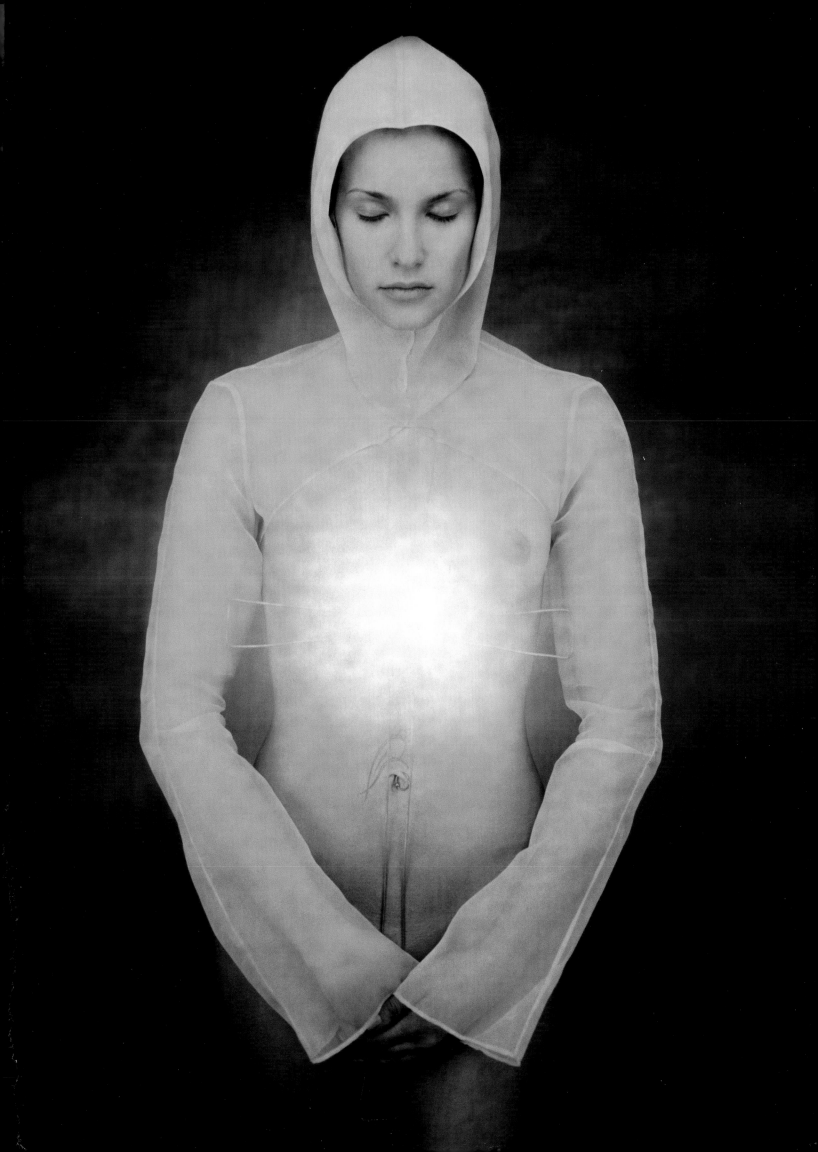

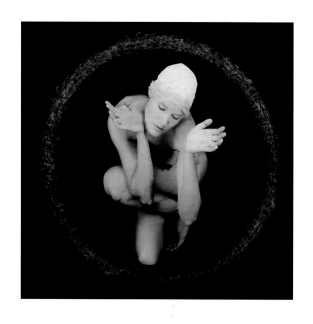